HOW TO LOOK AT SCULPTURE

Text and Photographs
by David Finn

Harry N. Abrams, Inc., Publishers

Editor: Beverly Fazio
Designer: Ulrich Ruchti
Associate Designer: Michael Schubert
Captions compiled by Susan Slack

Library of Congress Cataloging-in-Publication Data

Finn, David, 1921–
 How to look at sculpture: text and photographs/by David Finn.
 p. cm.
 ISBN 0–8109–2412–9 (pbk.)
 1. Sculpture–Appreciation. I. Title
NB1142.5.F56 1989
730'.1'1–dc19 88–25111
 CIP

Printed and bound in Japan

Frontispiece: Michelangelo. *Night* (detail from Tomb of Giuliano
de'Medici). 1524–31. Marble, length 76¾." Medici Chapel, San
Lorenzo, Florence

Front cover, clockwise from right: Antonio Canova. *Three Graces*
(detail). 1815–17. Marble, height 65⅝." Duke of Bedford, Woburn
Abbey, Buckinghamshire, England; Constantin Brancusi. *The
Muse.* 1912. Marble, 17½ x 9½ x 8." The Solomon R. Guggenheim
Museum, New York; Henry Moore. *Reclining Figure.* 1969–70.
Bronze, 91 x 135 x 61." Private Collection

Back cover: Alexander Calder. *The Door.* 1968. Painted metal,
53 x 29." Weintraub Gallery, New York

HOW TO LOOK AT SCULPTURE

Please renew/return this item by the last date shown.

So that your telephone call is charged at local rate, please call the numbers as set out below:

	From Area codes 01923 or 020:	From the rest of Herts:
Renewals:	01923 471373	01438 737373
Enquiries:	01923 471333	01438 737333
Minicom:	01923 471599	01438 737599

L32 www.hertsdirect.org

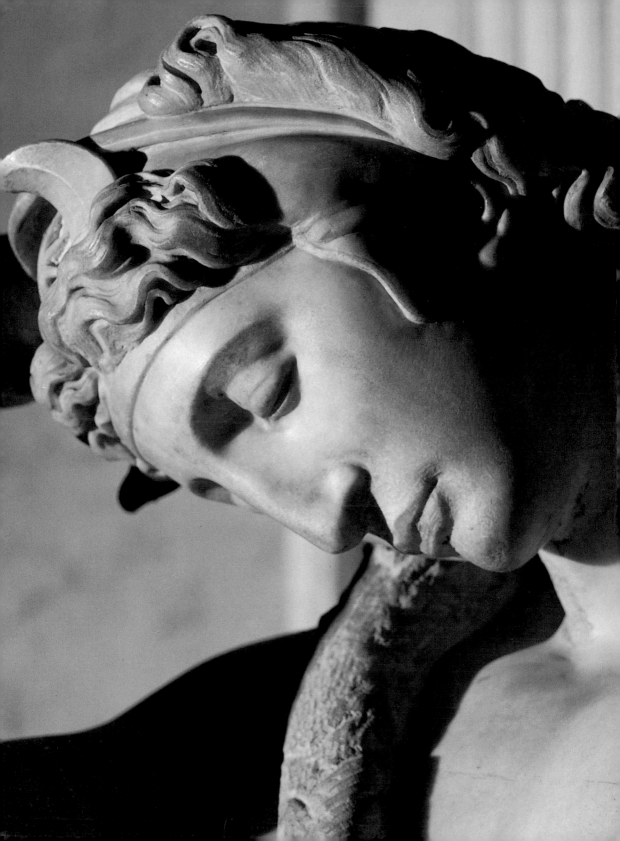

CONTENTS

PREFACE

When my book *How To Visit a Museum* was published, friends told me that it had served to increase their enjoyment of their museum adventures. There apparently had been a long-felt need to address that question, and, although I hadn't given any direct answers in my book, it seems as if I had provided enough useful hints to be of help.

Subsequently Paul Gottlieb, the president and publisher of Harry N. Abrams, Inc., suggested that I write a book on "how to look at sculpture." I have been involved in the world of sculpture all my life and have taken tens of thousands of photographs of sculpture for over twenty-five books, which is probably something of a record. But I wasn't sure how I might help readers appreciate sculpture the way I had learned to do over so many years. An art-historian friend of mine had a ready answer. "Just tell them to read our books," he said. That was good advice. But for those who were not immediately inclined to do so, perhaps I could present some thoughts that would put them in the right frame of mind.

It is certainly true that many fine writers have provided remarkable insights into the works of great sculptors, and I have had the privilege of working with and learning from a number of them; I have taken the photographs for books by such luminaries as Kenneth Clark, Meyer Schapiro, Frederick Hartt, John Pope-Hennessey, Fred Licht, John Boardman, Charles Avery, Stephen Spender, Sam Hunter, and Caroline Houser. And it has been most gratifying when these scholars have suggested that they learned something new from my photographs. Kenneth Clark, for instance, wrote that although he had taken a bus from the Florence Baptistery every day when he lived nearby and had always looked at the doors while waiting, he saw in my photographs aspects of the sculpture he had never been aware of before. John Pope-Hen-

nessey told me how pleased he was to have his text on Benvenuto Cellini published with my photographs, which he thought were among the best ever taken of the works of a Renaissance sculptor.

One of my greatest teachers of how to look at sculpture was Henry Moore, a dear friend for many years, whose work helped me understand what great sculpture can mean in our lives. The most fulfilling pleasure I have had as a photographer came from showing him on periodic visits to his home the latest series of prints I had made for a forthcoming book. He admired great sculpture from all periods, even those against which he had rebelled as a young artist—the classical sculpture of the Parthenon, the baroque sculpture of Gian Lorenzo Bernini, the neo-classical sculpture of Antonio Canova. When he looked at my photographs he would single out those which showed the tension and strength of the forms, often saying that he hadn't realized how good a particular sculptor was until he had seen these photographs. His reaction, along with the responses of the scholars with whom I had worked, encouraged me to feel that perhaps I could be helpful in guiding others to see with the same eye for form that has helped me in my work as a photographer.

For years, I had the conviction that sculpture should be photographed in museums and churches without artificial lights. My rationale was that either the sculptors themselves or knowledgeable curators had decided how best to view the work, and that I would do best to follow their lead. An additional consideration was that lights would be very complicated and time-consuming to use in such locations. It was the great English photographer and lighting genius Walter Nurmberg who taught me that proper lighting would produce better photographs and enable me to bring out the beauty of the subject more effectively. I tested his ideas in the Medici Chapel in Florence, where I had previously photographed Michel-angelo's magnificent sculpture in natural light; the new

photographs, with light carefully placed to bring out the forms, proved that he was right. They revealed aspects of the sculpture that I had never been able to capture in my earlier photographs.

Working on these books has enabled me to explore the wonders of sculpture through my camera eye for almost three decades. Seeing for the first time in a camera viewfinder a stunning view of a detail of sculpture emerge, which I know I will fix forever when I snap the shutter, is one of the most exhilarating experiences imaginable. And, of course, it is extraordinarily fulfilling to print those photographs in the darkroom and show the finished prints to knowledgeable authorities who find them to be a revelation.

It is my hope that through this book I can share with readers the excitement I feel in looking at sculpture all over the world. This is a general book on how to appreciate sculpture, not a lesson on any particular period or school or artist. It is not intended as a historic or comprehensive view of the art of sculpture, but rather as a collection of impressions and experiences accompanied by photographs that show what I have found in some of my own explorations. If readers will be inspired to look with a searching eye, think with a probing mind, and feel with a receptive heart, I know they will be enriched by what they see, and over a period of time the beautiful harmonies of forms they encounter will become part of their inner being.

David Finn

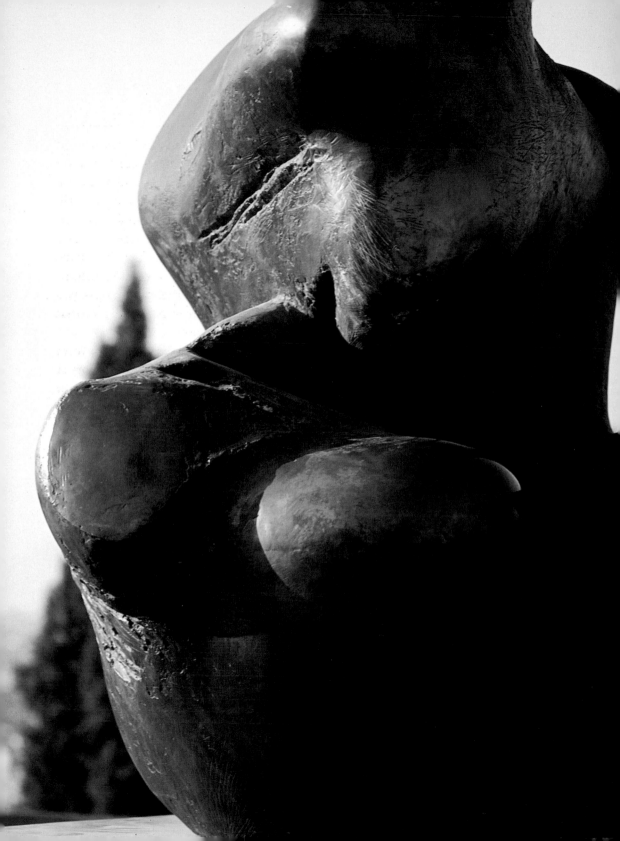

A DIFFERENT KIND OF REALITY

When you walk by an important sculpture in a museum, in front of a building, in a city plaza, or in a park, you are passing something that can open your eyes and mind to a new world. If you give it only a quick glance you will surely miss the experience. But if you stop, look carefully, walk around the sculpture, and watch it change as you see it from different angles, you will be able to make some astonishing discoveries. The aim of this book is to encourage you to take the time to see what is there and to give you an idea of what you may find if your mind is alert to what your senses tell you.

The first step in this adventure is to realize that a work of sculpture is quite a different reality from a painting. A sculpture exists in space like a human being, or like a mountain, tree, or cloud, and it needs to be approached as a terrain that must be explored in order to be fully appreciated. When you hike up a mountain you encounter something new and unexpected at each turn—rocks, trees, caves, clearings, views of the valley below. You are on an adventure full of surprising and exciting twists and turns that are challenging, intriguing, perhaps exalting, and each hike up the same mountain can bring new experiences. The same is true of climbing a tree. Every time you go up you may find branches you never noticed before, and as you move around you get a different feeling about the forms you come upon as well as about the landscape below. And when in an airplane you fly through clouds and see from above what you are used to seeing from below, you understand something about the sky you never knew before.

Henry Moore. *Two-Piece Reclining Figure: Points.* 1969–70. Bronze, height 12′ 6″. Forte di Belvedere, Florence

We are used to thinking of each person we know well as having a distinct individual appearance that is always recognizable and relatively unchanging. Yet in the inti-

mate caress of love, for example, as we explore the body of our beloved, we discover curves, hollows, ridges, muscles, bones, rippling shadows, striking highlights—looking fresh and new and more beautiful than ever, as if we had never seen them before. One of the great passages in T. S. Eliot's *Four Quartets* is a perfect description of that experience: "We shall not cease from exploration/And the end of all our exploring/Will be to arrive at where we started/And know the place for the first time."

This is the experience you can have when encountering a fine work of sculpture: adventure, curiosity, challenge, surprise, discovery, never-ending exploration. Sculpture is something that has been created by the artist to take you through space—not the outer space of the astronauts but the space in which you live. You can see the different shapes rise and fall and flow into each other as you look at the piece from different angles. You will find that you are being treated to a creation made by human hands as an answer to some inner vision that the artist had of life and the world. This is an echo of the real world or a response to it which the artist made in order to express his or her deepest feelings and to give you a new experience of life in the round. It is not an imitation of nature but a creation inspired by nature, designed by human hands as a work of art. The result helps us see nature itself in a new light, as if it too were created by an artist with forms that dazzle us in their brilliance.

Edmund Spenser in "The Faerie Queen" suggested that the forms of nature can be as great as those of the artist, reversing the common belief that art imitates nature:

...in the thickest covert of that shade
There was a pleasant arbour, not by art
But of the trees' own inclination made
Which knitting their rank branches part to part,
With wanton ivy-twine entrayld athwart...

Whether nature produces a work of art or artists are inspired by nature, you need to explore actively the forms you see in order to experience their impact. The initial view of a great work of sculpture may or may not have an immediate effect on you, but as you begin to look at its infinitely varied parts, something you see will strike you as beautiful. And you will make the all-important discovery that responding to a three-dimensional work of art involves a special kind of interaction between you and the object.

Essential to the appreciation of sculpture is *light*. Whether the light is coming from the left or the right, the top or the bottom, makes a crucial difference in the appearance of the forms. Soft light helps you appreciate subtle undulations; strong, direct light accentuates dramatic details. Or a strong light may be necessary to reveal the bulges of a figure that represent muscle and bone and give strength to the work, or the texture of tool marks that show the artist's personal touch. Light from above may throw deep shadows that obscure the forms below or create misleading or disturbing shapes, but it may be the only way to bring out the dramatic forms of the work that enable it to speak forcefully to you, as is often the case with Oceanic or African works which the artists carved in equatorial climate with the sun shining directly overhead. Light creeping around an edge of a sculpture can produce breathtaking outlines; light shining on a surface can reveal exquisite colors of patination. As the light changes on outdoor sculpture, the work itself is transformed. This is especially true of relief sculpture, which can look flat if the light floods directly on it but can be seen in all its glory when the light comes from the side. In a museum visitors are subject to the judgment of curators, who arrange the light as they see fit, and there's no way a visitor can change it. But if you are conscious of the light as you look around the sculpture you can take note of the revelation that comes when the light does something extraordinary to the

forms. One of the most exciting discoveries I have ever made was in Michelangelo's *Rondanini Pietà*, perhaps his greatest work, when I glimpsed the sensitively chiseled outline of the heartbroken mother and the fallen son as highlights at the edge of the sculpture.

As you become more and more involved with sculpture, you will find that it can appeal not only to the sense of sight but also to the sense of touch. That is especially true of what has been called "organic" sculpture, or sculpture that resembles the forms found in organic life, reminiscent of those found in humans and animals and in other forms of nature. The tactile and the visual aspects of organic sculptures relate to one another in a remarkable way to help you *feel* the qualities of the work.

Those who have had an opportunity to run their fingers over the surfaces of a masterpiece of sculpture know what a rare thrill it is. Touching the works is often prohibited in public places, yet physical contact produces a powerful response to the work. This is because the art of making sculpture is a sensual form of creativity. It grows primarily out of the emotional relationship we have to the human figure—our own to begin with, and more importantly those of others who arouse in us the passions associated with physical love. When we touch what sculptors have created we get the feeling that we are experiencing the same intense emotion felt by the artists when creating their works. Our hands repeat the experiences they had, and we become lovers of form just as they were.

I can best convey an understanding of this physical response to sculpture by describing one of my own experiences. Recently, I spent an afternoon—after closing hours—photographing the Michelangelo sculptures in the Accademia in Florence. I was able to obtain special permission to do this since I was working on a new book on Michelangelo. At the far end of a long gallery was the *David*, one of the most famous sculptures of all time. Along the sides of the gallery were the four *Slaves* and the *Matthew*.

Michelangelo. *Rondanini Pietà*.
First state, after 1552; second and third states, late 1563–64. Marble, height 76¾". Castello Sforzesco, Milan

I was all alone in the museum, with lights, camera, tripod, and even a special portable ladder to help me take photographs from different heights.

The *David* was, as always, pristine, awesome, spellbinding. It existed in a world of its own. I felt as if I could spend a lifetime standing below, looking up at the glorious forms softly lit from the skylight above, walking around to view it from all angles, aware that it was strangely beyond my reach, both physically and spiritually. *David* is so large that it is physically inaccessible from any position. My ladder raised me ten feet off the ground to somewhere between his ankles and knees. It is also unreachable in a metaphysical sense because it seems superhuman; one of the greatest sculptural achievements of all time. It was hard to believe that someone made of the same flesh and blood as the rest of us had created it.

The *Slaves* and *Matthew* were different, although in their own way no less great. My photographic lights were able to bring out every tool mark in those extraordinary works. They have been described as unfinished, since Michelangelo planned to continue carving them. But because of Michelangelo's unique way of working they were also complete works of sculpture. Every mark he made on the stone was put there with incredible sensitivity and with an eye toward its effect on the overall creation. He was constantly composing as he worked, as if he felt, to quote T. S. Eliot again, that "the time of death is every moment." He could die at any instant knowing that what he had created had the stamp of his genius in every part.

That is why in those roughly cut works one can feel especially close to Michelangelo as a living artist. We interrupt him for a moment while he is working, and we almost see him with his tool poised in the air. Then he disappears, and we are left with an intimate view of what he was in the process of creating. We see a wonderful symphony of forms, some roughly hewn, some with graceful lines curving around or running across the surfaces,

Michelangelo. *"Blockhead" Slave.* 1527–28. Marble, height 8' 7½". Accademia di Belle Arti, Florence

Opposite: Michelangelo. *Awakening Slave* (detail). c. 1519. Marble, height 8' 8¼". Accademia di Belle Arti, Florence

others with fine pebbly textures, and here and there a smooth passage of flesh and bone miraculously emerging in the stone.

I photographed feverishly that afternoon, with my camera darting in and out of all those surfaces, moving my lights around constantly to reveal the secrets of the sculpture. This went on for hours. I worked almost to exhaustion, and when I felt I had to call it a day, I turned off the lights, put my equipment away, and turned back for one last look at those masterpieces that had become imprinted in my innermost being. But I couldn't leave. I felt as if I were bound to the floor by some enormous magnetic force. My eyes could not tear themselves away from those mysterious forms standing in the shadows of the enormous gallery. Suddenly, an idea came into my head: perhaps I could touch them and feel with my fingertips the breathtaking texture of the stone, the sweeping forms flowing up and in and around, the ridges and bumps and smoothed out parts that made up the surfaces of the sculpture. I could only reach the lower sections, but that would be enough to give me a new sensation beyond what my eyes and lens had caught.

So I did, with indescribable rapture. I thought that no other sculptor could have created what I felt in those miraculous stones. There must have been a heavenly spirit in Michelangelo's fingers as they guided his tools, and I felt that spirit now transmitted like electric impulses through my fingers into my heart. I ran my hand again and again over those surfaces I could reach. It took only moments, but it was a timeless experience.

Somehow, I had needed to touch the sculptures in order to be able to tear myself away from them. Looking, even as intently as I had done, had not been enough. There had to be a climax, and the climax came when I could feel the stone.

I don't know of any testimony from the Egyptians, Chinese, Indians, Greeks, or Africans that touching sculp-

Michelangelo. *Awakening Slave* (detail)

Michelangelo. *Slave* (detail).
c. 1519. Marble, height 7′ 8⅝″.
Accademia di Belle Arti, Florence

ture is a key to grasping its essence. Even Michelangelo and his contemporaries were silent on the subject. I know Henry Moore felt keenly about it, and whenever he came across a cast of one of his own sculptures that he hadn't seen in a long time, he would bang it with his knuckles as if to make sure it were alive and well. He believed that it was the physicality of a sculpture, which can be experienced most directly through the sense of touch, that is one of its most vital characteristics.

Anyone who wants to understand sculpture should look for some opportunity to run one's hand over a beautifully shaped surface. Perhaps you can do this on a tour of a home that has some works of sculpture in its collection and where the owners would be delighted to have you share the enjoyment of their treasures. One acquaintance of mine says that whenever she visits the home of a collector, she always reaches her hand out tentatively on one sculpture to see if the owner will object, and if there is no outcry she knows she has a feast in store for her with the rest of the collection. Perhaps you will be lucky enough to pass by a fine work of sculpture that is either permanently placed or is on loan in a public area such as a park or a plaza. Or maybe you can sneak a quick touch in a museum when you're all alone in a gallery.

In most museums, there are conscientious guards who do their best to prevent you from directly satisfying this particular aesthetic appetite. There are reasons for the rule—excessive rubbing of a bronze can change the patina of the sculpture because of the oils in the skin, and similar problems could arise with stone or wood sculpture. Famous works are viewed by tens of thousands of people in the course of time, and the impact of vast numbers of fingermarks could be devastating if touching sculpture were permitted. So in order to preserve the works for future generations, museum goers must be deprived of one of the most rewarding ways of discovering the extraordinary forms created by a master sculptor.

Gian Lorenzo Bernini. *Rape of Proserpine*. 1621–22. Marble, height 88″. Galleria Borghese, Rome

Opposite: Gian Lorenzo Bernini. *Rape of Proserpine* (detail)

That is why the prohibition to touch sculpture in public places is such a problem. In a sense, we are like the blind man who has to learn to *see* with his hands. If you have ever watched blind people in a museum touching sculpture and exclaiming excitedly, "Look at that beautiful form!" you know that one sense can be trained to take over from another. We who can see but are forbidden to touch have to do the reverse. We have to train our eyes to feel the sculpture in all its parts and from every conceivable vantage point, as if we were actually touching it.

This sense of physical contact adds something ineffable to the experience of sculpture. There is no counterpart I can think of in painting or drawing. This is because a sculpture comes close to being as real as the body of another human being. Once when I was photographing Michelangelo's terra-cotta female *Victory* in the Casa Buonarroti (also in Florence) I suddenly gasped when my close-up lens discovered Michelangelo's fingerprint. I was with Frederick Hartt, the Renaissance scholar, and we both saw the fingerprint at the same time. We practically screamed at each other in excitement and felt as if Michelangelo were alive with us physically through this unmistakable imprint of a part of himself on an object that had a living presence there before us.

The sense of sculpture as a living presence can be demonstrated with a particularly tactile work such as Bernini's *Rape of Proserpine* in the Borghese Gallery in Rome. When first approached, it gives the impression to our contemporary eye of being extremely "fussy," with a crown on the head of Pluto, the hair of Proserpine streaming in the air, arms and feet flailing about, clothing draped with complicated folds around and through the figures. Most visitors examine the sculpture with a sense of curiosity, look briefly at the twisting forms, recognize that it is a rape scene, and move on.

If you look more closely, however, you can discover some of the palpably dashing qualities of the sculpture—

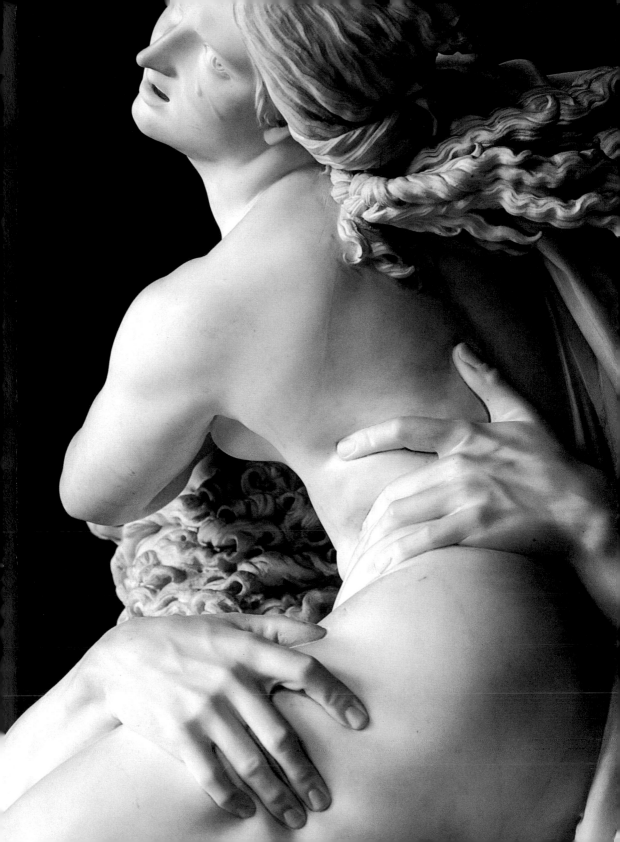

the blazing eyes of Pluto, his twirling beard and hair, his teeth seen in his partially opened mouth; the virginal, frightened look in Proserpine's eyes, her breasts barely seen underneath an encircling arm, tears streaming down her cheek. Then as you move to the right of the sculpture, you will be astonished to see the indentation of the flesh as Pluto's right hand presses into Proserpine's thigh and his left hand presses the flesh of her hip. That is when the eye begins to transmit the kind of sensory messages usually carried by the fingers. Proserpine's feet, swinging in the air, produce a series of violent movements that add to the scream you can almost hear. Continuing around, you come across the three-headed Cerberus and feel the fierceness of the cry from the head in the center. If you were to put your hand in the gaping cavity of the barking dog's mouth, surely, you feel, the jaws—with their savage teeth—would close around it like a clamp! Then you see the superb back of Pluto, his muscles rippling in the relative darkness at the rear of the sculpture, and the light coming around the right side producing the most exciting, lightning-like lines. Around Pluto's right side, his taut muscles reveal the great tension of his body. And, finally, you discover the incredible muscular knee and leg that make you *feel* the power of the mighty figure.

Walking around the sculpture, with your eyes peeled for lights and shadows and forms of flesh and hair and cloth, all making abstract patterns of unspeakable beauty, you are in effect touching all its parts with your eyes rather than with your hand. You have a sense of physical contact with the three-dimensional creation standing before you. When your eyes are doing the feeling, you have a very special kind of experience. It is not the touch of the material that provides the critical impression; it is as if your eyes have fingers that are able to explore the work from all sides.

Another famous "rape" sculpture also has an amazing interplay of forms that can keep the tactile-feeling eye

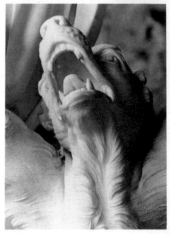

Above: Gian Lorenzo Bernini. *Rape of Proserpine* (detail showing head of Cerberus)

Top: Gian Lorenzo Bernini. *Rape of Proserpine* (detail of Pluto)

Opposite: Gian Lorenzo Bernini. *Rape of Proserpine* (detail)

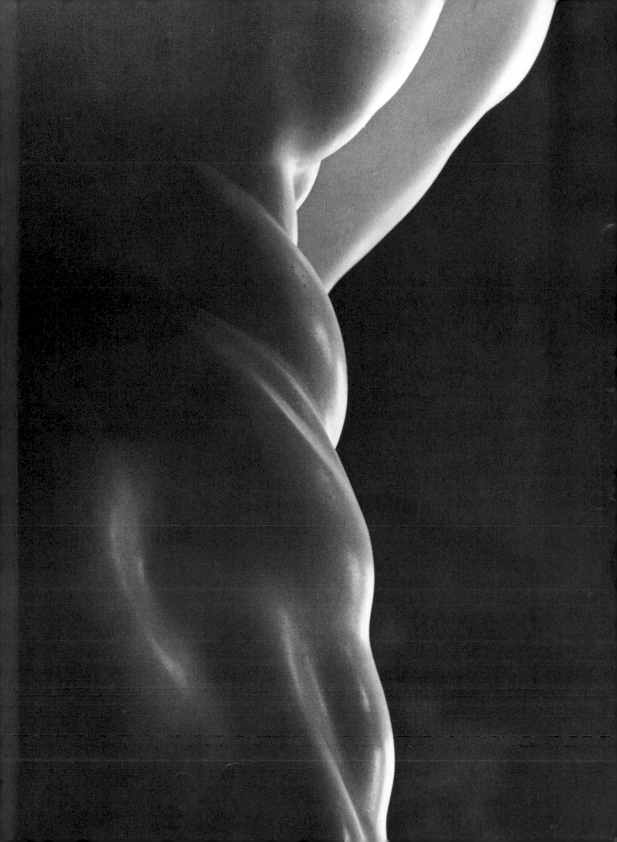

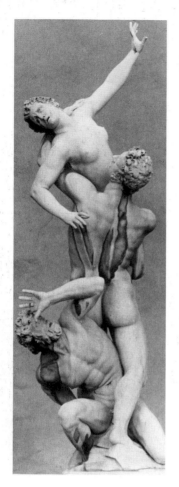

moving round and round—*The Rape of the Sabine* by Giambologna in the Loggia dei Lanzi in Florence. Three figures interweave around each other like a vine, arms inside arms, legs inside legs, limbs and torso playing against each other in brilliant compositions. This work preceded the *Proserpine* by several decades and doesn't have the dashing, violent, baroque qualities of Bernini's sculpture, but it has its own version of straining muscles, arms flung into the air, fingers pressing into the flesh of buttocks. Especially fascinating about this masterpiece is how you can discover juxtaposed faces and bodies in so many different ways as you move around the figures—the handsome face of the warrior staring up at the breasts of the struggling female, the man below holding his fingers up to his face in horror as he struggles unsuccessfully to save his loved one, the outstretched hands of the girl, the thrusting legs of the rapist. It is a brilliant composition, high up on a pedestal—far beyond anyone's reach and yet totally accessible to the searching eye that brings a sense of touch into the forms.

If you should happen to be in Florence and have a chance to see *The Rape of the Sabine,* be sure to look at the beautiful relief below the sculpture, which gives the context for the work above. Here, several groups of soldiers carrying off their women prizes, to the horror of the

Giambologna. *Rape of the Sabine.* 1581–82. Marble, height 13′ 3″. Loggia dei Lanzi, Florence

Right: Giambologna. *Rape of the Sabine* (detail)

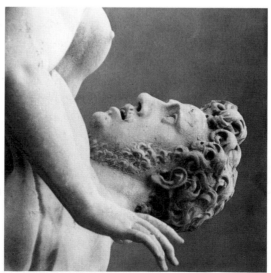

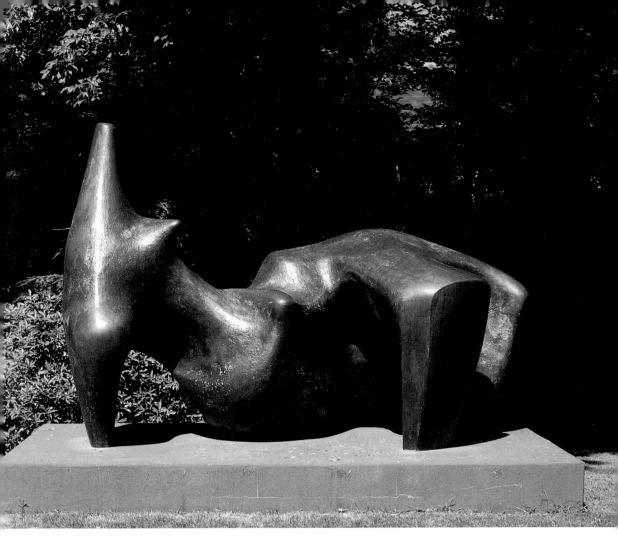

Henry Moore. *Reclining Figure.* 1969–70. Bronze, 92 × 135 × 61″. Private Collection

defenseless men crouching below, present a scene full of tension and interacting shapes.

One way to train the mind to see and feel at the same time is to hold a small work of sculpture in your hand. Henri Gaudier-Bzreska, a brilliant young sculptor who was killed in World War I at the age of twenty-three, created many such small sculptures. In the few short years of his life, Gaudier-Bzreska produced some of the most original and inventive works of the twentieth century. A good many of his sculptures are in the collection of the Tate Gallery in London.

Henri Gaudier-Bzreska. *Duck* (two views). 1914. Bronze. Tate Gallery, London

I recently held a small *Duck* by Gaudier-Bzreska in my hand and felt that it was an archetypal form that revealed the essence of unity in diversity—*unity* in the sense that it held together as an individual expression, *diversity* in the surprising variations that can be seen by turning it around. Looking at the sculpture straight on, you see a geometric representation of a duck with a large round circle for the eye in the head and a tail in the form of a triangle. With bulges here and there, it is a delightful exercise in geometry. If you look at it from the rear you can see an ingeniously shaped abstract form of several planes. From the top it has the appearance of a cliff with a canyon in the middle. And if you turn it over it looks like an organic form with a lip sticking out in the middle. Actually, different forms appear from every conceivable angle, and the genius of the piece is that it is spectacularly shaped no matter how you look at it; each different view gives you a new picture that the sculptor has created. Whenever you hold it in your hand, you can feel with your fingers the bulges and hard edges, flat areas and curved forms as you turn it, and touching it in that way enables you to grasp— both literally and figuratively—what the sculptor has created. You feel as well as see how ingenious he was in creating this marvelous invention which is so imaginative and yet so simple.

Henry Moore was probably the most prolific producer of small works in the history of sculpture, with literally hundreds of maquettes to his credit. He once said that working on a small sculpture made him feel "like God creating something out of nothing." But consider one of Moore's sixteen-foot monumental sculptures that couldn't possibly be held in one's hand—*Reclining Figure 1969*, which weighs several tons. A cast of this sculpture was once on loan to the New York Botanical Garden; it is now in the Open-Air Museum in Hakone, Japan (there are six casts in all). It is the kind of sculpture on which children love to climb (which Moore approved of since he

liked his sculpture to be physically enjoyed). It has perches, slides, and different levels to move up and down on. Visually, there are an almost infinite number of views to fascinate the exploring eye, from the cavelike lower end, to the rippling forms on the top of the sculpture, the bulging form on the back, and the towering head rising above. It is a sculpture so infinitely varied that you can always find in it something you never saw before. Even if it were located outside your home, and you could see it every day, it would be a source of endless discoveries. The tool marks alone are a source of fascination, for Moore was intrigued with the variety of textures he could create. The piece was originally carved out of styrofoam, then partially covered with plaster. In some areas Moore left the styrofoam texture, but in others he shaped the plaster with a variety of tool marks, some curling around, others straight slashes, still others cross-hatches, so that an array of drawings is clearly evident in the bronze cast.

Thus, you can turn a small sculpture like Gaudier-Bzreska's *Duck* around in your hand, you can climb figuratively or physically on top of works like Moore's *Reclining Figure,* or you can use your eyes to feel their way in and out of the work, discovering beautiful forms everywhere. This is the key to appreciating a three-dimensional work of art. There are literally an infinite number of vantage points from which to view it—not just front, back, and two sides, but 360° vertically, horizontally, and points in between. Just as sculptors look at their work from all angles while creating it, you create your own impressions when you look at it as a viewer. You may even discover a vantage point the sculptor only felt intuitively and never actually saw. Indeed, you may be the only one who ever looked at the work from that precise point. The view you have discovered becomes your own; it belongs to you alone, because you found it. And if you feel that it is beautiful, you will carry away the sense of a lovely form that has made you a richer and more sensitive human being.

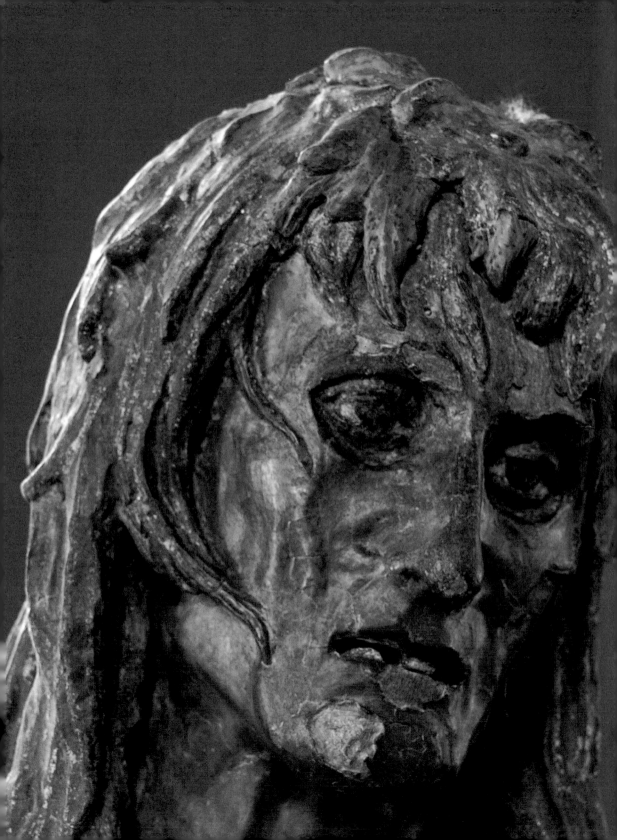

WHAT MAKES A SCULPTURE GREAT?

Inviting the eye to explore the many different forms and spaces is integral to the art of sculpture. But that alone does not make a sculpture great. After all a rock of any shape, size, or form can invite the eye to look at it from different angles, and yet a rock per se is not a great work of sculpture. Wherein lies the difference?

The question of greatness is difficult to answer in relation to any work of art—a poem, a musical composition, a painting. There is no universal agreement on what greatness is in any particular art, or even which works of art deserve to be called great. Moreover, each art has its own characteristics. Describing what greatness is in a poem does not necessarily help in describing what greatness is in a work of sculpture.

It has been said that what is great about a poem is that which is left out in a translation. The same can be said about a work of sculpture: what is great is that which is left out in a copy. In 1873 when Michelangelo's *David* was removed from its original site in the Palazzo Vecchio and placed in the Accademia, the four most distinguished professors of sculpture of the time signed a statement attesting to the excellence of the copy that was put in its place. But any visitor today who looks at both the original and the copy can see that the former is an overpowering work of art and the latter is not.

Being able to make the distinction of greatness for oneself is crucial to the appreciation of any art. You must *feel* the quality of greatness in the forms if you are to respond fully to the art of sculpture. I believe that a great work of sculpture contains forms that make a powerful impact on the mind, an impact that is sustained, even grows stronger, the longer and more often you look at it. There is a tremendous tension in a great sculpture, a

Donatello. *St. Mary Magdalen* (detail). 1455–56. Polychrome and gilt wood, height 74″. Baptistery of San Giovanni, Florence

tension that makes every part of the work quiver, from the top to the bottom, the back to the front. The forms may or may not strike you as beautiful, at least beautiful in the traditional sense of *lovely* or *graceful*, but their inner strength produces a monumentality that can be over-powering and unforgettable. Like a philosophical idea that gives you a new insight into a fundamental question of life and death, once you have been exposed to a great work of sculpture you feel as if the images in your head will forever bear its imprint. I do not mean that you will necessarily remember the actual forms clearly enough to recreate them; but the impact is so profound that you feel as if the forms have become part of your inner self.

There are many sculptures you may think are fine but not great because they do not make this kind of impact. Usually these will delight you from one angle or another, or one part or another. A great work is of a different order. In such a work the sculptor has managed to exercise his genius in every aspect of the sculpture, and there is liter-ally no section of the work—and no angle from which it is viewed—that does not produce an equally powerful effect.

That is why a great sculpture has the capacity to be appreciated by many generations and many cultures. Cer-tainly tastes change, and opinions about the greatness of a particular sculptor will vary over a span of time, but when a sculpture appears great to our eyes we believe that it contains a revelation that will endure forever. It has a sort of magical quality, and the effect can be overwhelming.

How can one learn to recognize the quality of greatness? By being exposed to it: by knowing which sculptors are considered great in the history of art, studying them, trying to understand some of the words used to describe their masterpieces in books, catalogues, reviews, or by knowledgeable friends. Most importantly, the more you look the more you will learn. When you begin to find that your emotions are aroused by the discoveries you make in the forms, and you are getting excited about some of the

things you are seeing, then you know you are beginning to appreciate what makes a great work of sculpture great.

One of the most rewarding benefits of travel is the ability to see great works of art and be personally enriched by memorable aesthetic experiences. That is particularly true of sculpture, and it is worth a special trip abroad to see some of the greatest masterpieces of all time. If I had to choose several works that I would go around the world to see, among them would be Donatello's *Magdalene,* in Florence; Claus Sluter's *Well of Moses,* near Dijon, France; and Michelangelo's *Moses* in Rome. They were created from the fourteenth through the sixteenth centuries, that incredible period when some of the greatest masterpieces of all time came into being.

Donatello's tragic figure of Mary Magdalene can be seen in the Museo dell Opera del Duomo in Florence. It is an unequalled story of human pathos in painted wood. Everything about the figure expresses a sense of the human tragedy—the sad, blue eyes staring out of hollow sockets; the thin line of her partially opened lips with broken white teeth showing within; the yellow streaked hair twisting in tortured curves; the gaunt cheeks and neck with bones protruding in the flesh; the hands with their long fingers arched in deep prayer and profound humility; one knee slightly bent, making a pitiful but touching effort to show her sense of grace; her bare feet scrawny and veined. It is a harrowing figure that wrenches the heart. But Donatello's masterpiece is more than just a realistic portrayal; its greatness lies in the tension that can be felt in every part of the body. Even the spaces around the arms and between the hands seem to vibrate with an unseen energy. It is a rare experience just to stand in front of the *Magdalene* for a few minutes and feel the deep pain she has suffered during her lifetime. Intuitively you sense her presence, as alive today as she was centuries ago, and you are overwhelmed by the ravages of human degradation and the miracle of redemption.

As is always the case in museums, this masterpiece is surrounded by additional masterpieces—more works by Donatello and sculptures by Luca della Robbia, Nanni de Banco, and others. Inevitably one moves from one to the other, spending the briefest time on each. Unless you force yourself to stand just in front of the *Magdalene* to absorb all of her qualities, you will only get a limited feeling of what she is all about. And if you move quickly on to another sculpture, the profound experience that you can feel in this figure is diluted by the mood one finds in the other works in the gallery. The best you can do is to try to fix the feeling somewhere in your brain so it can be remembered and relived as you reflect on the work—and possibly study it through photographs or reproductions in books.

Some sculptures are situated so that you can be with them alone. One of the most remarkable experiences any lover of sculpture can have is to visit the Chartreuse de Champmol near Dijon and see the *Well of Moses (Puits de Moise)* by the fourteenth-century French sculptor Claus Sluter. Originally created for the Duke of Burgundy, the *Well of Moses* is now situated in a large glass enclosure on the grounds of a mental institution. When you visit the institution to see this sculptural masterpiece, nothing— and no one—else there diverts your attention, and the glass enclosure makes you feel as if you are in a museum created just for that work. You can stay there for hours, walking around and around the work, examining all the details. It is well worth making a special trip, as my wife and I did, just to see this superb work.

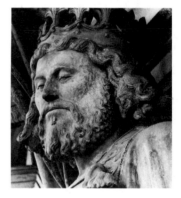

Claus Sluter. *Well of Moses* (detail of David)

Opposite: Claus Sluter. *Well of Moses* (detail of Jeremiah). 1395– 1405. Painted stone, lifesize. Chartreuse de Champmol, near Dijon

The *Well of Moses* consists of six larger-than-life-size prophets—Moses, David, Jeremiah, Zachariah, Daniel, and Isaiah—in what was originally painted stone. (Some of the paint still remains in the details.) Above the prophets, angels hover under the roof of a cathedral-like structure. Each figure has an extraordinary monumentality, and each expresses the individual character of its subject in its facial features, stance, dress, and pose.

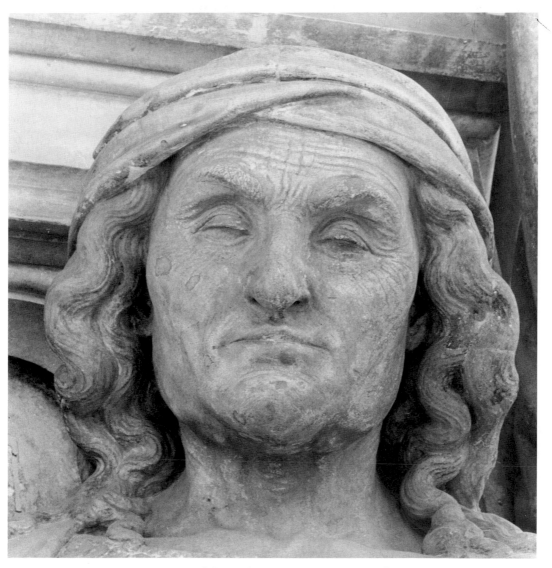

Moses is a grand and noble figure, dressed in a long, flowing robe, majestically standing with the tablets of the Ten Commandments (paint still showing) in his right hand. His beard divides into two strands that stretch below his breast, and his eyes flash under a wrinkled brow and godlike horns. To the left of Moses as you walk around the structure is David as a young man, slightly bearded

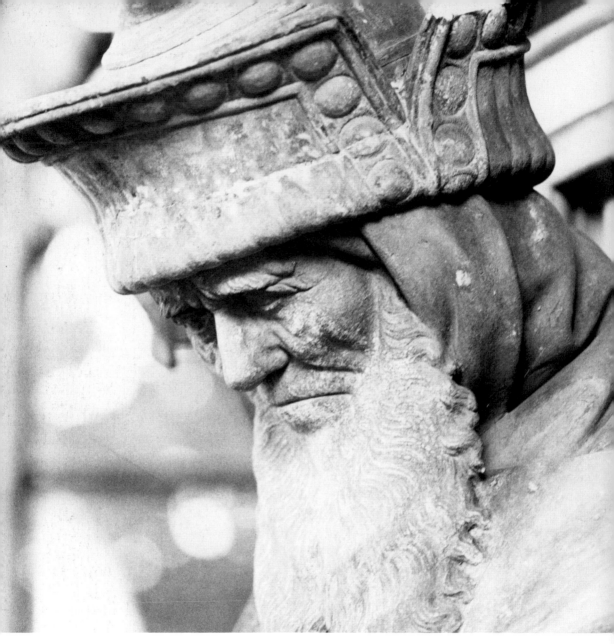

and with a full head of curly hair, crowned, wearing a sweeping robe with little harps in the fringes, and holding a scroll in his left hand. To David's left is Jeremiah, with his prophetic face under a turban-like head covering, and holding a book with fingers in the pages he looks as if he is about to deliver a prophetical statement to the people. To

Claus Sluter. *Well of Moses* (detail of Zacharia).

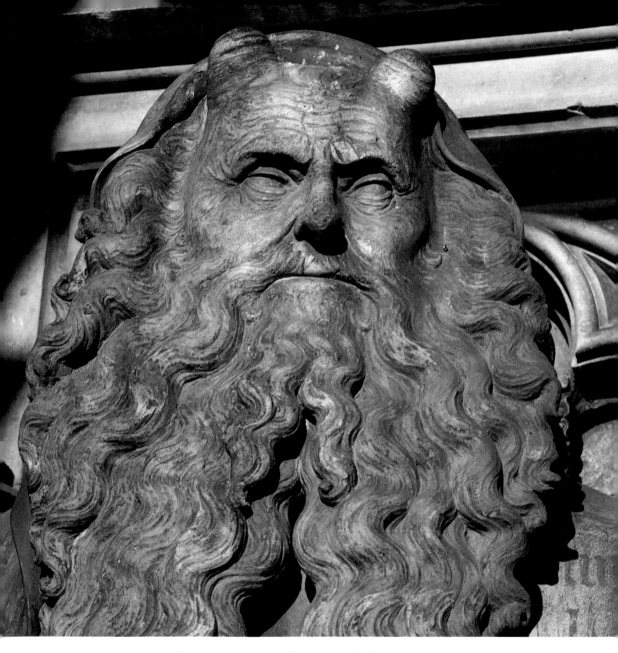

Claus Sluter. *Well of Moses* (detail of Moses)

the left of Jeremiah is Zachariah with his sorrowful, downward glance, his full beard, an odd but beautiful hat sitting on his head, and his arms held at his sides (his left hand also holding a scroll). Of all the figures, Zachariah is the most commanding. Then comes Daniel, with a fierce look on his face, a different kind of turban on his head,

long robes, holding a pose that makes him look as if he is about to stride forward, carrying his scroll with both hands. And finally we see Isaiah, simply dressed and wearing no hat, bald, his beard almost as long as that of Moses but not as full, and with a sad, faraway look in his eyes, his right hand holding a scroll, his left clutching a book, a pouch hanging at his left side.

The texture in the sculpture is remarkable. Skin, hair, leather belts, metal buckles, cloth slippers showing under the robes, clothing with mighty folds—all are rendered to perfection in the carved stone. The faces of the figures have enormous strength of character and great conviction. The angels above, beautifully painted (the celestial blue can still be seen), some praying, some singing, some holding hands to their faces, are equally stunning. And the architecture behind the figures—with its columns and beautifully carved capitals—is a perfect frame for these extraordinary figures. The whole scene can make shivers run up and down your spine.

There is, of course, a more famous sculptural *Moses*—the one created by Michelangelo and installed in San Pietro in Vincoli in Rome—that can be seen without competing works in the area, but not without crowds of tourists milling about. This is more idealized than Sluter's work, and grand in another sense—a Moses who has taken on the appearance of the Lord himself and is capable of speaking in a thundering voice to all of humankind.

A friend of mine once told me how Michelangelo's *Moses* first opened his eyes to the art of sculpture. He had taken his teenage daughter on her first visit to Rome and was driving her around to show her all the sights. She wanted to see *Moses,* but he wasn't particularly interested. So he drove her to San Pietro and waited in the car while she went inside to take a look. Minutes went by, and he began to get impatient. Finally he decided to go in and find out what was keeping her. He found her standing in front of the sculpture, staring at it. Following her eyes, he was

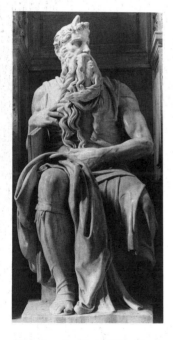

Michelangelo. *Moses.* 1513–16. Marble, height 88″. San Pietro in Vincoli, Rome

Opposite: Michelangelo. *Moses* (detail)

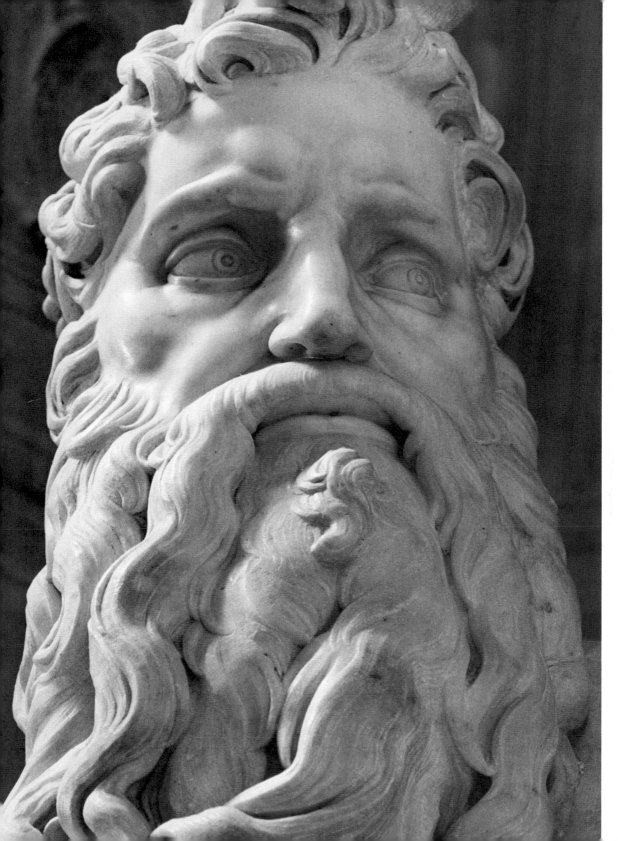

astounded by what he saw. He thought the figure was about to rise from its seat and walk over to him. Michelangelo's *Moses* had for my friend a mesmerizing reality. In the enormous tension of his posture, his fiery glance, the noble position of his hands, the striving knee coming out from under the cloth, the grandness of the entire figure, there was something so extraordinarily monumental, so filled with straining energy, so spiritual, that he was overwhelmed.

There is almost always a crowd around Michelangelo's *Moses* in the church. Tour groups keep coming in and out, all with guides speaking in different languages. I often worry that people think only about the fame of this particular work of art, and that they are awestruck by its celebrity rather than moved by its greatness. It could be the same as standing on a street to watch a famous dignitary pass by, or looking at the changing of the guards: the event may be more important than what one actually sees and feels.

When seen in its natural half-light, with shadows helping to bring out the strength of its forms, the impact of *Moses* is stupendous. From every angle the head has a stern, religious, charismatic look. Here is a leader of men! Here is someone who has just talked to God and is bringing his message to the world—a message that will reverberate through the ages. The horns, said by some to be an ancient sign of supernatural powers and by others to be the result of a mistranslation of the Hebrew word (beams of light, not horns, came from his head), somehow add to the nobility of the figure. The long flowing beard; the arms and hands, with their great muscles and veins; the garment superbly flowing over the figure—all are part of a masterwork that is thrilling to see. The longer one looks at it and discovers the patterns of light and shadow —the way the eyes are set below the tensed eyebrows and the muscles of the forehead; the folds of skin beneath the eyes and on the cheek; the fingers stretched out to hold the

strands of the beard; the shoulder muscles rippling alongside the draped garment; the toes firmly placed in sandals—the longer one examines all these and more, the more fully one can absorb the endless qualities of this masterpiece.

Sometimes a person will put a coin in the light machine near the sculpture and for a few moments you see the work with great clarity. This is revealing, but it is also disturbing, for if the light is not carefully beamed at the sculpture, it tends to flatten the forms, depriving it of the sense of grandeur.

On the sides of *Moses* are two gentle figures by Michelangelo—*Rachel* and *Leah*. The inner beauty of the figures can be seen by looking at them from different angles and by concentrating your attention on details. Leah's face is particularly beautiful from her left side and Rachel's from below on her right. These sculptures don't have the monumentality of the *Moses*, but they have a quiet dignity that can be spellbinding.

After absorbing the impact of these figures, I find it almost unbearable to look at the sculptures above the *Moses*. These were done by one of Michelangelo's assistants and are, by comparison, static and ugly. Just as looking straight into the sun blinds one to everything else, the brilliance of Michelangelo's *Moses* prevents anyone who looks at it with open eyes and an open heart from responding to a lesser work.

It would be a good idea after visiting *Moses* to go for a little walk or drive around the city to let your mind rest. If you were to move too quickly on to another work of art immediately after, the deep imprint that would make the experience unforgettable might be marred by oversaturation. It needs a period of digestion to be fully absorbed in your system. In that way *Moses* will become part of your soul as truly as if the Old Testament had come alive.

Experiencing great works of sculpture in the deepest sense involves an encounter with an object that is unlike

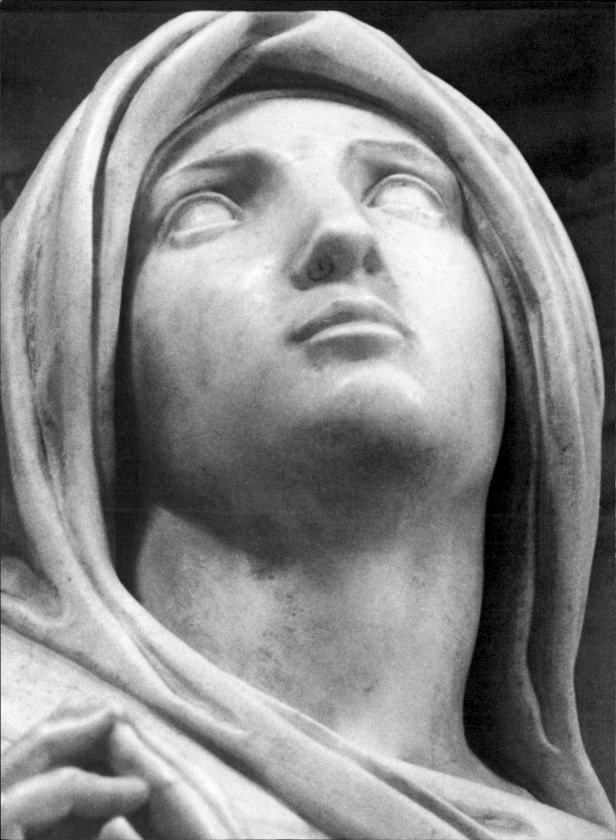

anything else one comes across in the course of one's life. Sculpture is a *thing* that has a separate and independent existence. Although it may be modeled after a living subject it is a being unto itself. It is not human. It is not alive. It is still and silent, frozen in an instant of time. Yet there is something eternal about it.

The use of stone and bronze as two of the basic materials of sculpture expresses the intent of the artist to create something that will be long-lasting, but the eternity in the forms does not lie in their indestructibility. Shelley demolished that idea in "Ozymandias" when he wrote:

I met a traveler from an antique land
Who said: Two vast and trunkless legs of stone
Stand in the desert. Near them, on the sand,
Half sunk, a shattered visage lies,
Whose frown and wrinkled lip, and sneer of cold
 command
Tell that its sculptor well those passions read
Which yet survive, stamped on these lifeless things,
The hand that mocked them and the heart that fed;
And on the pedestal these words appear: "My name is
Ozymandias, king of kings: Look on my works,
Ye Mighty, and despair!" Nothing beside remains.
Round the decay that colossal wreck, boundless and
 bare
The lone and level sands stretch far away.

It was vain for Ozymandias to think that his sculptured portrait, and along with it his fame and power, could last forever. Although some sculptures have survived thousands of years, there is no guarantee that they will still exist thousands of years from now. Yet when we see a great work of sculpture we have a sense that its achievement has an immortal quality about it. The truth embodied within it is eternal. When our eyes and heart and hand are open to the beauty of a great sculpture, we feel that we are in touch with the infinite and the everlasting.

Michelangelo. *Rachel* (detail from Tomb of Julius II). 1542. Marble, height 69½". San Pietro in Vincoli, Rome

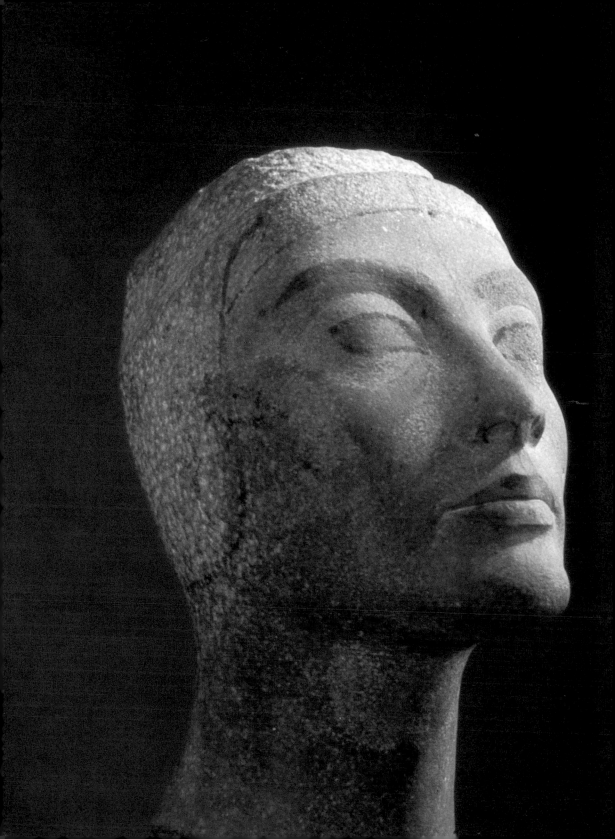

EXQUISITE DETAILS

Something about a great work of sculpture draws the eye to details. One looks incredulously at the muscles, bones, fingernails, hair, facial features, creases of flesh, and folds of clothing in the sculptures, marveling at how precisely the sculptor has rendered them. The same care and sensitivity is evident in an abstract work by the way joints are made, different materials combined, space circumscribed. It is as if the key to greatness lies inch by inch in the handling of surfaces which can be appreciated to the fullest when one examines small areas of the work.

Very large sculptures can have details that are as finely wrought and beautiful as very small sculptures. In Luxor, Egypt, on the east bank of the Nile, where Shelley's "traveler from an antique land" saw the remains of Ozymandias (and where one can still see fragments of this very sculpture), a giant head of Rameses II lies on the ground. There is no "sneer of cold command" in this face; rather, there are sensitive features carved with the skill of a master. Although the head is only a fragment, the part that is preserved is in excellent condition. The details are magnificent—the eyes, the lips, the ears, the fullness of the cheeks, the indentations of flesh at the corners of the mouth, the geometric lines of the headdress. The quality of the details draws one around the sculpture to see their effect from different points of view, and they are beautiful to look at no matter where one stands.

It is not verisimilitude that makes details great. Wax museums have extremely naturalistic renditions of the human physiognomy, yet no one believes they are great sculptures. What is remarkable about details in a great figurative work of sculpture is that they ennoble the human form. The sculptor's genius opens our eyes to aspects of the human figure we never before fully appreciated. Or we feel ourselves uplifted by a powerful rendition

Queen Nefertiti. Dynasty XVIII, 1362–49 B.C. Quartzite, height 13⅓". Egyptian Museum, Cairo

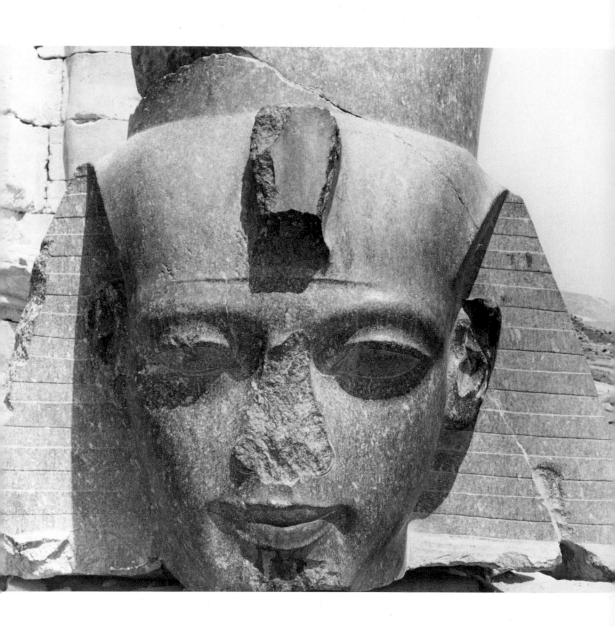

King Ramesses II (detail from
seated colossus). Dynasty XIX,
1290–24 B.C. Dark gray granite,
height of head 91″. Luxor, Egypt

of idealized forms created by the sculptor. When we look at the head of Rameses II we sense the dignity of man as experienced in a society that believed in eternal life.

Faces found in ancient Egyptian sculpture are among the noblest ever created. To see how beautiful some of them are we have to perform the mental gymnastics of blocking out the features that are strange to us—the artificial beards or unfamiliar headdresses. In some figures the heads look as if they were done yesterday. One of the most spellbinding sculptures I have ever seen is the head of Nefertiti in the Cairo Museum; the eyebrows and eyelashes are gently painted on a flesh-colored skin, while the lips practically glow with a soft reddish tint. Looked at from all sides, it is among the most captivating faces carved by human hands, and it is easy to see why this young queen, who reigned more than three thousand years ago, has been hailed as one of the most beautiful women who ever lived. Another Nefertiti bust, in Berlin, is more famous because it is more complete and is painted with brilliant colors, yet it is oddly less enthralling.

The bodies of the figures in monumental Egyptian sculptures are no less impressive than the faces. You have to get used to the traditional postures—the rigid standing position, the seated position with hands folded on raised knees, the block figure suggesting a garment covering the body in a crouched position. Also you have to look for beauty in an animal head which has the same quality of nobility as a human figure. But there is an exquisite delicacy in the rendition of details—the way the muscles are smoothly and sensitively carved, the way hieroglyphics and small figures are incised into the stone, the way curves and squares and angles intersect with each other to form perfect abstract compositions.

Equally, fine details can be found in sculptures of other cultures. It is quite amazing to look at the small designs and figures in Chinese sculptures. The tomb figures, created three or four thousand years ago, are the epitome

45

of sensitivity and grace. The abstract designs in bronze implements and jade ornaments have an astonishing delicacy and feeling for form. And the shapes of some of the utilitarian vessels are composed as fine works of sculpture. But it is the details that are so compelling. The faces and figures of people, animals, and imaginary beings have a quality of execution that is exquisite.

Each culture makes its own special contribution to our sculptural experience. Ancient Japanese sculptures combine what might otherwise seem to be the incompatible qualities of supreme gentleness and unrestrained ferocity. Perhaps this reflects the nature of the Japanese personality. Sculptures of the Buddha convey a sense of peacefulness and quiet introspection. They are sometimes painted gold to convey a sense of eternity. Even in the monumental Buddha of Kamakura, which is sixty-six feet high, the details of the facial features, the hands, and other parts of the body are composed with a fine sense of design. The forms of these elegant Japanese sculptures are unlike those of the Egyptians—more geometrical, more stylized, more abstract; but they are equally controlled. On the other hand the fierce sculptures of warriors, with their intense facial expressions and aggressive stances, seem to contain enormous energies about to explode. Their sculptural qualities are as impressive as those of the quiet Buddhas. The compositions are brilliantly worked out, and the details of the grimacing faces and the complicated clothing worn by the warriors evoke the sense of great sculptural mastery of form. When looking at these figures you may find them strange, exotic, their faces almost like masks seen at Mardi Gras; but they are not caricatures. They are monumental portrayals of characters that were meaningful to the contemporary society, and if you recognize how finely wrought the details are, you will be able to experience their fine esthetic qualities.

Pre-Columbian sculpture in the Americas has its own unique distinction. One of the earliest periods, Olmec,

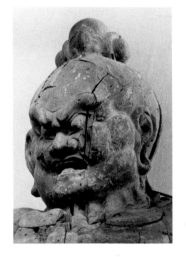

Warrior. 13th–15th century. Wood, over lifesize. Nara (probably from Temple), Japan

Opposite: *Standing "Kwannon" figure.* Kamakura Period, c. 1186–1333. Wood, height 5′ 7″. Kuramadera, near Kyoto

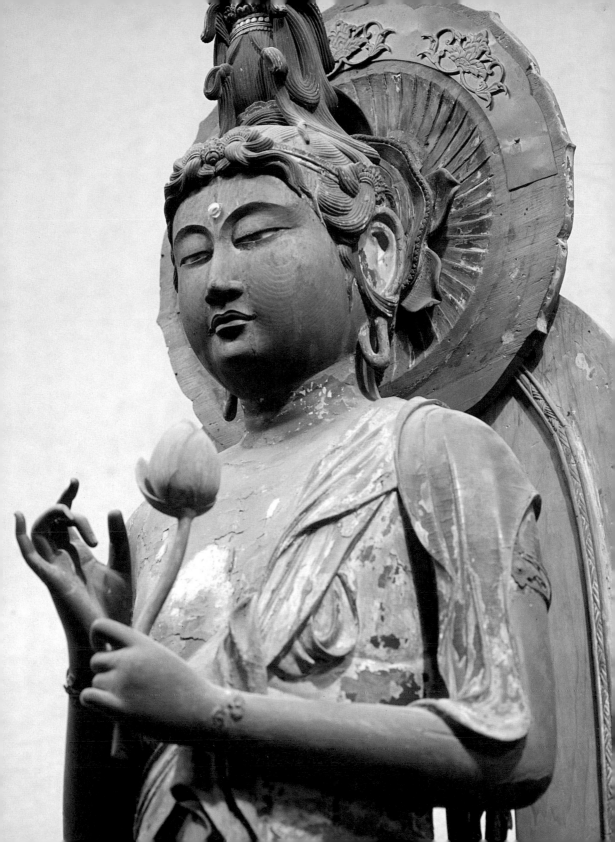

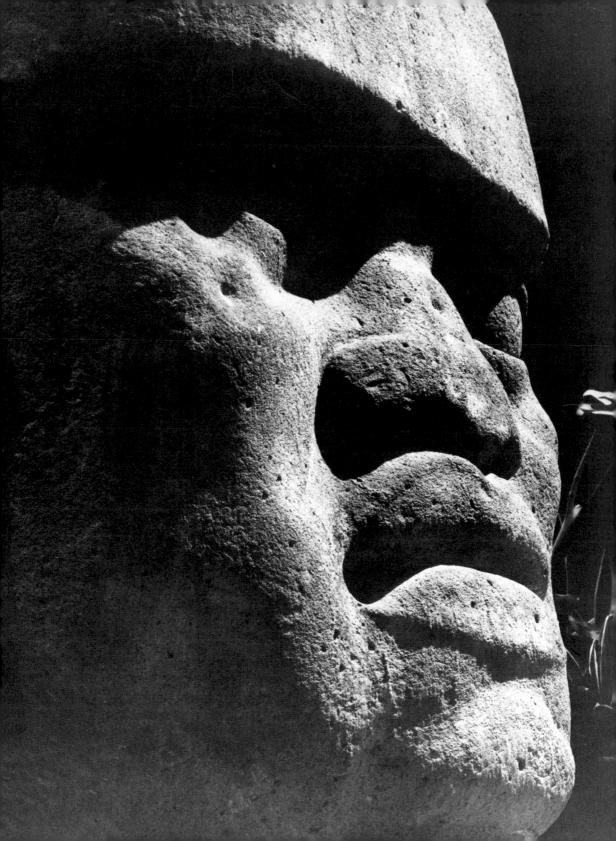

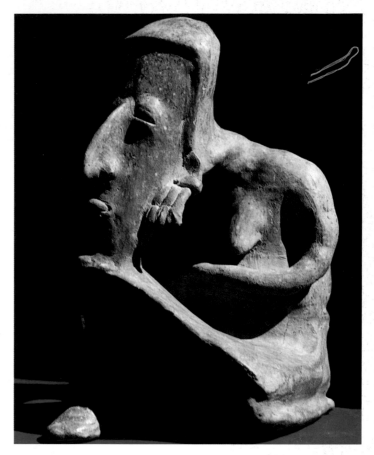

Opposite: *Colossal Head.* Olmec Period, c. 1200 B.C. Basalt, over lifesize. Museo Nacional, Mexico City

Right: *Seated Figure.* Evolved Pre-Columbian style. Clay, height approx. 6″. From the Patsy R. and Raymond D. Nasher Collection, Dallas, Texas

produced some of the most striking sculptures ever created. Among their masterpieces are a number of colossal heads carved in stone about eight or nine feet high and weighing fifteen to twenty tons. The dynamic facial characteristics of these enormous works achieve a majesty that must have had an enormous impact on the people of that era. Smaller works from later Pre-Columbian periods, many of them on painted clay, are remarkably expressive, with the shapes and positions of the figures conveying different moods. Here mastery of details may be found in the simple abstractions of eyebrows, the shape of a nose, the rendition of teeth in an open mouth, a ridge of flesh bordering perfectly formed lips, the form of a hat.

49

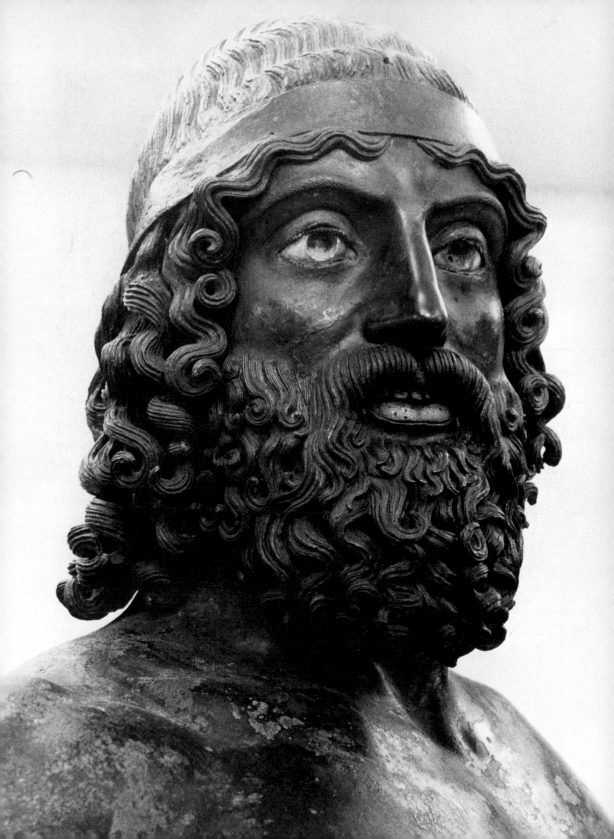

Opposite: *Warrior A* (detail).
Greek, mid-5th century B.C.
Bronze, height 6' 7½". Found in
the Ionian Sea near Riace Marina.
Museo Nazionale, Reggio di Cal-
abria, Italy

Right: *Warrior A* (detail)

Below: *Warrior B* (detail). Greek,
mid-5th century B.C. Bronze,
height 6' 7½". Found in the Ionian
Sea near Riace Marina. Museo
Nazionale, Reggio di Calabria,
Italy

Details in ancient Greek sculpture are different from
those of Asian, Egyptian, and Pre-Columbian sculpture.
The Greeks discovered beauty in drapery, and in the
flowing garments of their figures one can find a veritable
symphony of fluted forms. As the light falls on these
beautifully designed shapes, one is amazed at the inven-
tiveness with which they were created. No fold is exactly
like that of its neighbor, and this produces infinite variety
in the forms, all masterfully playing on each other, as if
created by divine hands.

The faces of monumental Greek sculptures were not
intended to represent individual human beings but rather
gods in human form. At least that is the impression they
give. The *Charioteer* in Delphi displays a godlike perfection
in every detail, down to his metal eyelashes. His marble
eyes seem to have the power to see the invisible. The Riace
bronzes in Reggio Calabria have copper lips and silver
teeth that look as if they could devour their enemies. The

hair of the beards curl into vigorous patterns that are manifestations of superhuman virility. Muscles are tensed to show great strength. Hands, toes, genitals, knees, buttocks—are all rendered beautifully; each part could be a sculpture in itself. Perhaps most remarkable of all, insofar as details are concerned, veins subtly protrude in precisely the right places as if blood were actually flowing through them. The Greeks were extremely close and accurate observers of human anatomy: I learned, for instance, that the outer ankle of a foot is lower than the inner ankle by admiring the details of Greek figures.

The joy of looking at the Parthenon sculptures in the British Museum and the Acropolis Museum comes from the discovery of similar details. A muscular chest, beautifully carved, stands out in sharp contrast to the damaged stone that surrounds it. Folds of a garment produce magnificent patterns on a fragmented figure. The head of a horse appears out of nowhere. Light falls on a muscular shoulder, the wheel of a chariot comes into view, a cow's head rears up, the noble face of a warrior is juxtaposed against the snorting head of a horse, the veined legs of other horses prance across the stone. When these sculptures were covered with paint and placed high on the inner walls of the Parthenon they undoubtedly created a different impression; all the details that are so beautiful to our eye in their present condition would have been subordinate to the overall effect as decoration on the building. It is our good fortune that we can see them as the sculptors themselves saw their own work when they were creating it.

Medieval sculpture is in many respects the antithesis of classical sculpture; however, these artists had their own sense of detail, and it was just as refined in its own way as that of the Greeks and Egyptians. In the sculptures on medieval churches and cloisters are the most wonderful renditions of birds, trees, boats, houses, and people. In the great abbey at Moissac, France, details of sculpture produced in the eleventh and twelfth centuries show musi-

The Charioteer (details). Greek, c. 477 B.C. Bronze, height 69″. Archeological Museum, Delphi

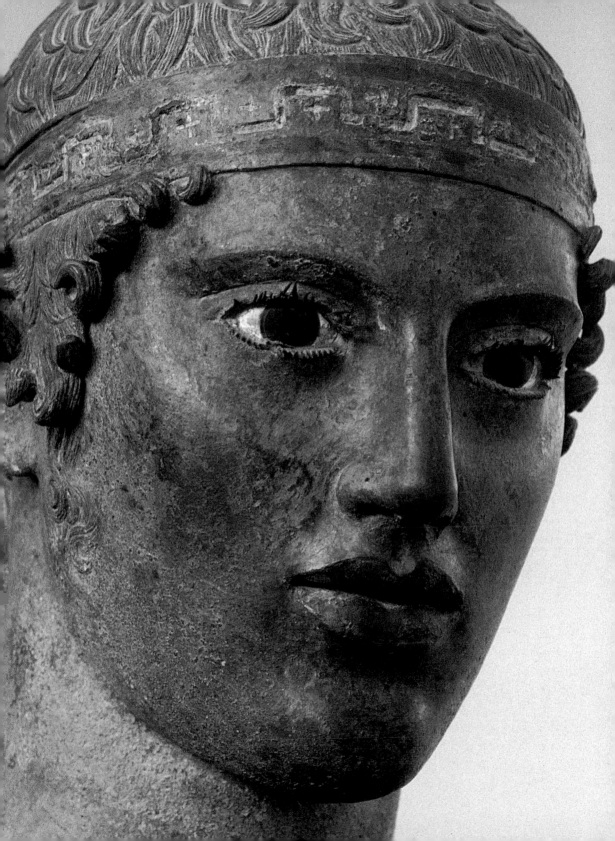

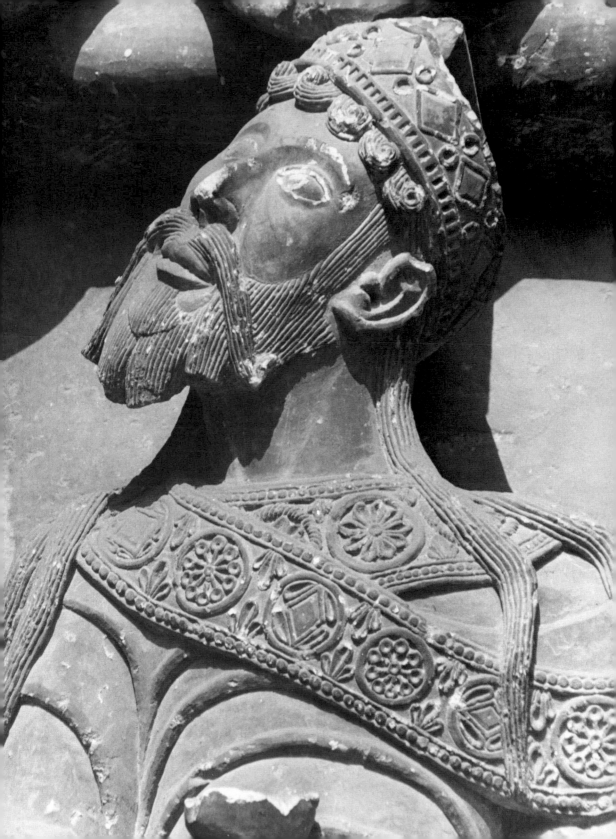

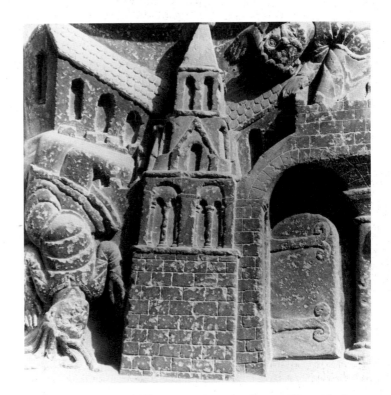

Opposite: *An Elder* (detail) from Tympanum of South Portal. Before 1115. Stone. Abbey Church of St.-Pierre, Moissac

Right: *Fall of the Idols of Heliopolis* (detail) from East Wall of the Porch. c. 1115–30. Stone. Abbey Church of St.-Pierre, Moissac

cal instruments, goblets, crowns, scrolls, staffs, and pieces of furniture. The clothing of saints have wonderfully wrought fringes and jewels. Food and bowls are clearly depicted on tables, even in some of the smallest scenes. Animals are shown with their appropriate hair, wrinkles, and tails. Dragons, never seen by a human eye, look incredibly real and frightening. Great attention is paid to architectural details in the sculpture—arches, windows, columns, bricks, roofs, towers. Although the figures have different proportions from those we are accustomed to (sometimes with tiny heads on long bodies and at other times the reverse), close attention is paid to hair, wrinkles, and facial features as well as expressions of awe, anger, suffering, or joy.

The bronze doors of San Zeno Maggiore in Verona, which also date back to the eleventh and twelfth centuries, are one of the marvels of Italian medieval sculpture.

Forty-eight panels cast in bronze are bolted to an ancient wooden door, with the wood showing in between the panels. Here and there in the borders are faces, figures, and decorative forms, some broken off and others in perfect condition. All the forms on the door are incredibly strong and dynamic, as if the sculptor were shouting at the top of his voice the message he wanted to convey. The full-bodied bronze, masterfully handled, adds to the strength of the forms. There is a bewildering effect of figures all over the place.

Each individual panel is a masterpiece of design and sculptural monumentality. In the expulsion of Adam and Eve from the garden, for instance, three figures emerge from the background and can almost be seen in the round. Gestures and stances dynamically convey the drama of the event. Adam and Eve clutch giant fig leaves to their private parts. The angel, clothed in a long, flowing skirt, whose swaying wings stretch over half the panel, makes it clear to the sinners that they are being banished forever from Paradise. The rhythm of the bodies, feet, and arms of the figures constitutes a woven chain, echoed by the imaginative forms of the fig trees that fill the rest of the space. Even the bolts on the borders of the panel seem to be part of the sculptural creation. All the components are arranged in a harmonious design that dazzles the eye.

The same beautiful patterns appear on other panels. Often lacy foliage is interspersed with figures doing the strangest things, such as flying in the air like a Chagall painting. In the borders the gargoyle heads, which stand out as high relief, seem to stare out into space, with mouths open, as if in awe of the events taking place in the panels.

An important consideration to keep in mind when looking at medieval sculpture is that the artists attempted to portray the essence of things rather than their appearance. Thus in a striking figure of Saint John in St. Mary's Abbey, Yorkshire, England (c. 1200–1210), purity of soul

St. John. c 1200–1210. Stone, life-size. St. Mary's Abbey, Yorkshire, England

Opposite: Lorenzo Ghiberti. *Soldiers of Israel* (detail) from East Door, "Gates of Paradise." c. 1435. Gilt bronze, panel size 31¼" square. Baptistery of San Giovanni, Florence

is evident in the noble facial expression and the pensive look in the eyes. Yet there is a passionate love of detail in medieval sculpture as in that of any other period of history.

A new kind of realism came into being with the advent of the Renaissance, and among the most brilliant sculptural masterpieces of that era are the Baptistery doors of Florence. The south door, created in the fourteenth century, was the work of Andrea Pisano. The north and east doors were created in the fifteenth century by Lorenzo Ghiberti. All three are considered masterpieces. As with the San Zeno doors, these are remarkably low reliefs, and many people tend to look at them as if they were paintings rather than three-dimensional works. However, as with sculpture in the round, the changing light falling on the reliefs produces different effects and gives them a sense of physical reality that cannot be found in any flat work of art.

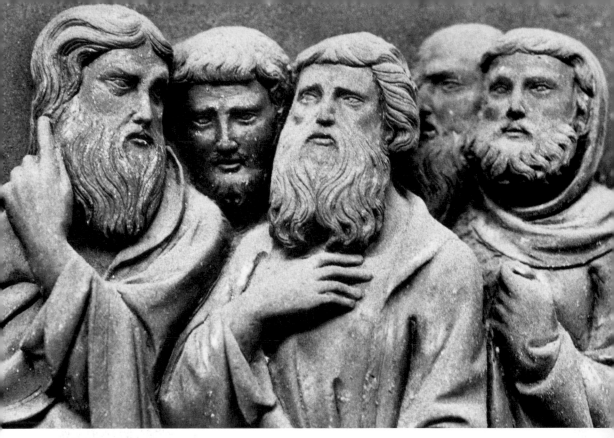

For the south door, Pisano created an astonishing series of twenty-eight reliefs, twenty on the life of John the Baptist and eight on the Cardinal and Theological Virtues. Ghiberti devoted fifty years, or virtually his entire working life, to twenty-eight reliefs on the north door and ten reliefs on the east door. The latter was considered at the time to be the ultimate sculptural masterpiece, and Michelangelo's famous description of this door as worthy of being the "Gates of Paradise" is quoted repeatedly to the crowds of tourists who can always be seen standing in awe in front of it. It is fascinating to see how the sculptors modeled the tiny figures that are so monumental in their effect and realize with what great care they chased their works after they were cast, incising the surfaces to create amazing textural effects.

The panels of Pisano's door feature beautifully modeled figures with details of flowing robes and angels' wings in

Andrea Pisano. *Zacharias Struck Dumb* (detail) from South Door. c. 1336. Gilt bronze. Baptistery of San Giovanni, Florence

Opposite: Lorenzo Ghiberti. *The Entry into Jerusalem* (detail showing Jesus and the crowd) from North Door. c. 1404–24. Gilt bronze. Baptistery of San Giovanni, Florence

some, and rocks, birds, and trees in others. Ghiberti's reliefs were deeper and more realistic; they show groups of people dressed in contemporary clothes. In the north door they are still somewhat static, but in the south door where there are almost freestanding sculptures the details become a tour de force. Also in the frames of Ghiberti's doors are several faces, including two self-portraits. The work was gilded to give the whole surface a quality of outstanding richness. Some of the panels of the east door have been restored and can be seen in the Museo dell Opera del Duomo, where the effect is marvelous to behold.

As with all medieval and Renaissance doors, it is almost impossible to stand long enough in front of them to absorb all of their qualities. Most visitors find themselves unable to spend more than fifteen minutes looking at all three doors, even if they have opera glasses to help look closely

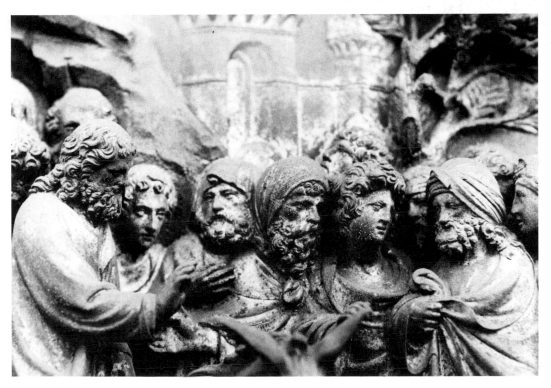

at each section. There are only so many times a person can say, "Fantastic! Fantastic! Fantastic!" But they *are* fantastic, and you should keep looking at them as long as you can. The trick is to let yourself gasp at those details of the sculpture that you find most astonishing and then proceed from marvel to marvel.

The search for details in the Baptistery doors is an adventure, and you feel as if you have made a wonderful discovery every time you come across something you never saw before. It is not that the artist hid them in hard-to-find places but rather that in a quick, overall glance you notice only the basic forms of the sculpture: you get a general impression and perhaps look at one or two specific parts, and then move on. These artists spent years planning and executing the work and put heart and soul into every aspect of it. So you can be surprised and delighted when you stay a little longer and begin to find those breathtaking details that make the sculpture so stunning.

I was particularly complimented when, shortly after my book *The Florence Baptistery Doors* was published, Henry Moore did a series of drawings inspired by my photographs. It was as if after our many years of friendship and collaboration during which I had photographed so many of his works, he was returning the favor by creating drawings based on my photographs.

The passion for detail brings out the inner resources of sculptors and inspires them to produce works of great strength. This was clearly so with a relatively unknown sixteenth-century sculptor named Heinrich Brabender, whose works I first came upon through my friendship with Henry Moore. Moore was in Munster, Germany, in the late 1970s in connection with the installation of one of his sculptures. While he was there, the director of the Munster Museum, Dr. Paul Pieper, showed him the works in the collection. In one gallery Moore stopped in amazement, exclaiming that these works were by a very great sculptor he had never seen. Pieper explained to him the

Top: Heinrich Brabender. *Last Supper* (detail showing Christ with Peter and John). c. 1490. Baumberger stone, length 72½". Marienkirche, Lübeck

Middle: Heinrich Brabender. *Ecce Homo* (detail showing Second Pharisee). 15th century. Baumberger stone, length 72½". Westfälischen Landesmuseum für Kunst und Kultursgeschichte, Munster

Bottom: Tilman Reimenschneider. *Kneeling Figure of an Angel*. Early 16th century. Limewood with remains of color, height 25". Victoria and Albert Museum, London

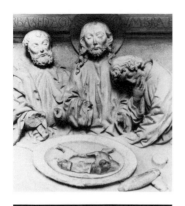

story of Heinrich Brabender, whose finest work was removed from the face of the Munster Cathedral during the Anabaptist revolt and thrown in the stone walls around the city, where they had remained buried until the mid-twentieth century. Once discovered, they were installed in the museum, and although some of the work was still in fragments, careful restoration showed how superb the sculptures were. Moore wanted to buy a book on the work of Brabender, but none had been published. He then said that if Pieper would write a text for such a book, he would write an introduction and would ask me to take the photographs.

Over the next several years all this came to pass, and the book was published in 1984 by a German publisher. I went to Germany several times to take the photographs, not only to Munster but to other towns and cities in Westphalia as well. Among the characteristics of Brabender's sculpture that were especially striking were the details he created in his works. In one figure of a Pharisee, for instance, the wrinkles and the expression on the face of the man are so realistic that one can't help feeling a local townsman was the model. There is a stubble on his chin and cheek like a five o'clock shadow, which I had never before seen on a sculpture. And even though some of the sculpture was fragmentary, I marveled at the cloth of a cloak, the tassels on a belt, the folds in a hat. Brabender was also a master of drapery in the classical tradition, and even on a fragmented torso of Christ, the folds of the cloth against the bony stomach and chest were gracefully designed.

The sculptures by Brabender, in a church called Marien Kirche in Lübeck, were miraculously saved when the church was bombed during World War II. They include a Last Supper scene that shows a table set with food, complete with loaves of bread so realistic that they look as if they could be eaten. There is also a plate with meat on it (oddly enough it looks like a piglet, which would

have been highly unlikely in a Jewish traditional service). Sitting around the table are Christ and the apostles, with a symphony of folds in their robes.

None of these details is in itself what makes the sculpture great. The greatness is in the monumentality of the forms throughout the work, the emotional impact of the figures, the sense of profound tragedy seen in some of the faces, the sensitive beauty in others. But somehow these overpowering qualities are heightened by the presence of details that show the genius of the sculptor, and which increase one's sense of awe in his masterly achievements.

It is interesting to compare Brabender's stone carvings with the wood sculpture of his more famous contemporary Tilman Riemenschneider. The former is more realistic, the latter more stylized. Yet the feeling for detail is extraordinary in both.

Sometimes it is clear that a sculptor intended to dazzle onlookers with his incredible details. That certainly is the case with Cellini's world-famous *Saltcellar of Francis I* in the Kunsthistorisches Museum in Vienna. It is only about ten inches high and fifteen inches long, and yet it contains so many details that descriptions of this work alone would be worthy of a book in itself.

The basic forms are two gold figures—one male, one female. The male figure, representing the sea, has a full beard and a wonderful head of hair held in place by a dark-colored ribbon. Every muscle in his front and back and his stretched-out legs and arms are shown in minute detail. The same is true of the beautiful nymph, apparently representing earth, with her lovely, small breasts, a slightly swelling belly, and full thighs. Her head is held high, crowned with a magnificent tiara made of sparkling jewels. At the side of these two figures is a tiny temple, just a few inches high, and yet its details are fabulous. There are Corinthian columns with blocks of stones in the walls, two "giant" standing sculptures at either end, and four

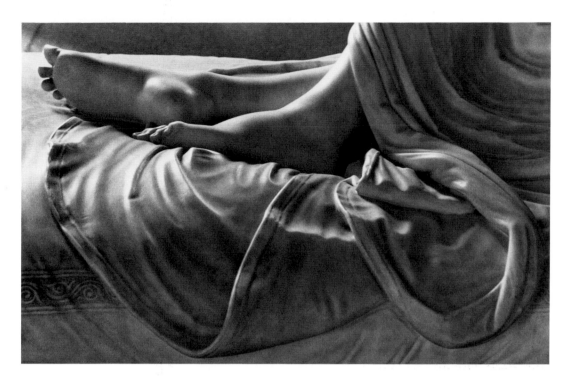

Antonio Canova. *Pauline Bonaparte Borghese as Venus Victorious* (detail). 1804–8. Marble, length 78⅝″. Galleria Borghese, Rome

seated sculptures on the corners. On top of the temple is a reclining female nude, beautifully modeled. The entire structure floats on a "sea" of gorgeous jewels. In it you can find dolphins, sea horses, and other fishes rearing their heads. Floating in the sea is a strange boat with the head of a man carved into the bow. Below the sea of jewels are eight figures, four reclining men and women representing the seasons, and four heads representing the four winds. The whole sculpture is a miracle of detail. King Francis I is said to have uttered a cry of astonishment when he saw the *Saltcellar* for the first time, and all of us who have seen it since in the last four hundred years can understand why!

The nineteenth-century sculptor Antonio Canova was scrupulous in the rendering of such details as furniture, pillows, and clothing as well as flesh, hair, and the palm of a hand. He seemed to have magical fingers that could turn stone into whatever material he chose to render. He was so

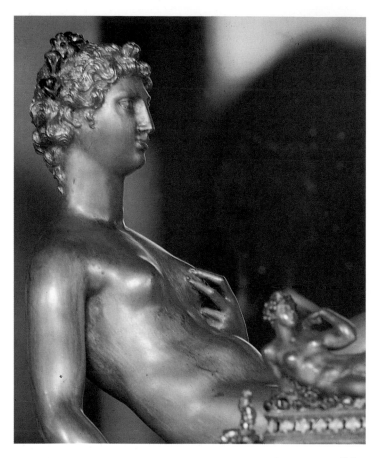

Benvenuto Cellini. *Saltcellar of Francis I* (details). 1539–43. Gold with enamel, 10¼ × 13⅛". Kunsthistorisches Museum, Vienna

skillful that many lovers of sculpture have been put off by what they consider mere technical virtuosity rather than deep and lasting sculptural values. A friend of mine who went often to the Borghese Gallery in Rome to enjoy the Bernini sculptures used to stand in horror as visitors would cluster around Canova's *Pauline* and exclaim in awed tones how wonderful it was that the sculptor had been able to so accurately render the creases of the sheet on which the half-nude woman was resting, the fluffiness of the pillows behind her, the myriad of folds in the gown spread out beneath her feet, the quality of flesh in her limbs. "What does this have to do with sculpture?" my friend would ask angrily. "It is like an illustration in

stone." However, if one has an open eye (and mind) one can find superb sculptural qualities in these details. The beauty is not in the resemblance of the stone carving to real sheets, pillows, gowns, and flesh but in the breathtaking lines and surfaces Canova created in those details. Clearly, the sculptor had a passion for producing striking textural effects, and his genius enabled him to create magnificent forms out of these details. Because they were so fascinating to him, one can recognize and appreciate his greatness with special clarity and force when looking at that aspect of his work. It becomes evident that his purpose was not to copy nature, but to use nature as a model and invent his own symphony of forms based on that model.

Sculptors who are inspired by nature can make masterpieces out of details. For instance, it is fascinating to look at the way sculptors handle the tails of horses on equestrian monuments. This may seem bizarre, but consider the great equestrian sculptures of history—the *Marcus Aurelius* in Rome, the *Gattamelata Monument* by Donatello in Padua, the *Monument to Bartolommeo Colleoni* by Andrea dei Verrochio in Venice, the *Monument of Cosimo I* and *Hercules Slaying the Centaur* by Giambologna in Florence, the *Monument of Constantine* by Bernini in St. Peters in Rome, the *Monument to Charles III* by Canova in Naples, the *General Sherman Monument* by Augustus Saint-Gaudens in New York. In each case the horses are sporting tails that are beautifully designed. Some have lovely curving lines, others have overlapping strands of hair, still others are tied in a knot, which is in itself a delightful sculptural element. In equestrian works, a clumsy tail is a giveaway of a clumsy sculpture. And there are other details to look for: the positioning and rendering of the horse's legs; the eyes, nostrils, mouth, and veins in the horse's head; the rendering of stirrups and leather straps; and most of all, the way everything interrelates as you move around the sculpture and look at it from different angles.

In less naturalistic sculpture, there are different kinds of details on which to focus. A work by Auguste Rodin, for instance, can deeply move a viewer the way soft flesh and the well-defined muscles and bones within are contrasted with hard stone. Intense facial expressions, a wrinkled brow, a broken nose, flaring nostrils, thick lips, the tilt of a head, the position of arms and legs, the writhing of the body, or the intertwining of two or more figures reveal the mood and spirit or character of the figures represented.

When a sculpture is less representative, as is the case of Constantin Brancusi's head that is almost a simple oval form, the eye is still drawn to details that somehow encapsulate the power of the work. One finds just the vaguest hint of a nose or lips, or a knot in the hair in the rear of the sculpture, and suddenly the whole form comes alive. In Alberto Giacometti's standing figures, bulges and indentations representing different parts of the body seem to contain the inner secret of the sculpture. If the light is right, you can discover in the midst of the unique sculptural landscape of one of his portraits the socket in the center of the eye, which gives the impression that the

Below left: Antonio Canova. *Equestrian Monument to Charles III* (detail). 1807–19. Bronze, over lifesize. Piazza del Plebiscito, Naples

Below right: Giambologna. *Hercules Slaying the Centaur* (detail). 1595–1600. Marble, height 9′ 7½″. Loggia dei Lanzi, Florence

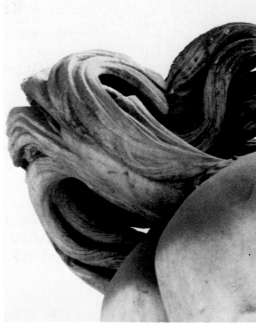

Right: Alberto Giacometti. *Diego* (detail). 1954. Bronze, height 24″. Collection of the Sara Lee Corporation, Chicago

Below: Gian Lorenzo Bernini. *Equestrian Statue of Constantine the Great* (detail). 1654–70. Marble, over lifesize. St. Peter's, Rome

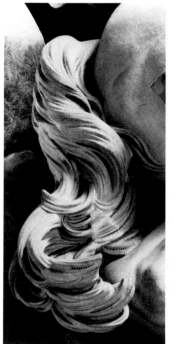

subject is actually looking out at the world—or directly at you. In a purely abstract work, the rods, steel plates, wire, glass, or plastic all have details that can be as compelling and exciting to the eye as Nefretiti's painted lips, the *Charioteer*'s metal eyelashes, or Canova's creased sheets.

To delve into the quality of a great work of sculpture and get beyond that first, quick impression and the subsequent walk-around to see it from different angles, focus your eye on details. Narrow your range of vision to small sections of the work, note how ingeniously the master sculptor worked to make the forms conform to some inner sense, and rejoice in your ability to discover the secrets in the details that bring you face to face with the essence of its greatness.

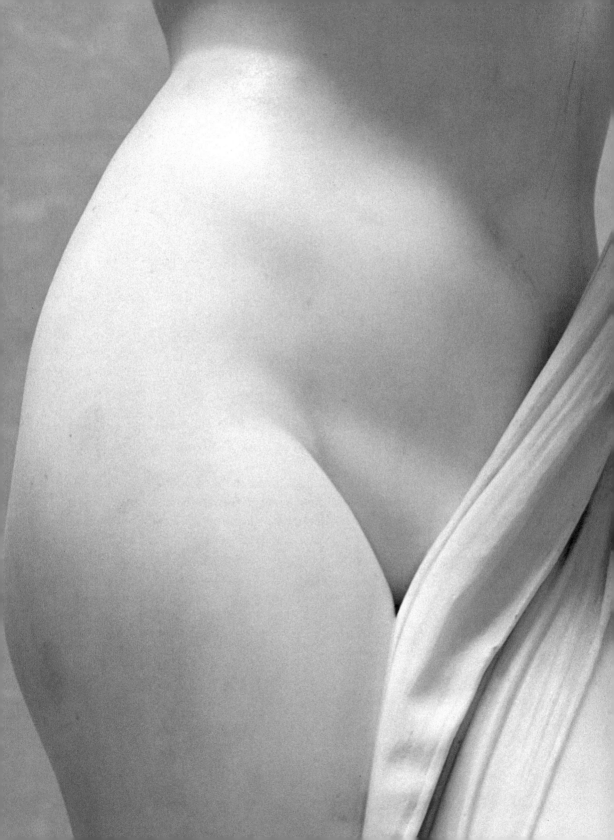

NAKED BEAUTY

A major subject of sculpture in many periods of history has been the human figure. Often the figure is naked. This differs from the other visual arts, since landscape and clothed figures predominate in painting, drawing, and printmaking. The distinction has become less evident in modern times when nonfigurative forms in sculpture have become increasingly common. Also, of course, there are many famous paintings and drawings of nudes in the history of art. However, taking the medium of sculpture as a whole during key periods of artistic achievement, naked figures have clearly been a dominant theme.

It is not enough to say "naked" when describing sculptures of the human figure; *naked beauty* is closer to the mark. Artists who are moved to probe the three-dimensional world for the forms that satisfy their creative urges are emotionally involved in the nakedness of the figures they represent and strive to bring into being the ideals that excite their passions. This is what Jules Romains calls "the adoration of the flesh."

The archetypal character for this aspect of sculpture is considered to be Pygmalion, the mythical Greek artist who fell in love with his sculpture of Venus. To his great joy, the gods brought his sculpture to life, and she became a real woman, Galatea, with whom he could fulfill his love. However, sculptors do not in fact dream of their naked beauties coming alive. Their object is to create a work of art that immortalizes their vision of beauty. The poet Rabindranath Tagore sensed this when he wrote:

> The secret whispered in the hush of night to
> the ear of your love is wrought in the perpetual
> silence of stone.

There is no doubt that the beauty of the human figure has an eternal quality about it. This can be seen in the art

Antonio Canova. *Three Graces* (detail). 1815–17. Marble, height 65⅝". Duke of Bedford, Woburn Abbey, Buckinghamshire, England

of dance. A fine ballet performance can be spellbinding as we watch the movements of the scantily clad dancers together with the accompanying music. The closer the figures come to actual nudity, the more awesome those experiences are likely to be. Unless the ballet is very explicit the dancers are not likely to be sexually arousing, but they are beautiful to our eyes in a sensual way. We have a heightened awareness of the exquisiteness of a lovely naked body and see it as a vision of immortality— or at least of a wished-for immortality.

Dance is an art form that is close to the art of sculpture. Dance excites our eyes and our feelings for a moment in time that is unforgettable; sculpture is forever fixed in one position that can be looked at repeatedly and always reveal something new.

When we are in the presence of a sculpture of a naked figure by a master we see an ennoblement of the earthly human being. We may see beings of our own sex or of the opposite sex without feeling the representations are erotic, but the sculptures touch us deeply as evocations of our deepest physical emotions.

The religions of the world have proven to be an inexhaustible source of inspiration for the rendition of the ideal man and woman. The Greek and Roman pantheon of gods were particularly rich in this respect. Hinduism has its own special approach to the nudity (and eroticism) of the gods. Buddhism features the almost-naked male Buddha in positions of quiet introspection. The Judeo-Christian tradition has been more limited in this respect, but from the fourteenth or fifteenth century onward it did provide Adam and Eve, David, Christ, Mary Magdelene, Saint Sebastian, and a few others as subject for naked sculptures. Only Muhammadism is devoid of any figurative reference since such representation is strictly forbidden.

As you walk through a museum in which there is a fair amount of sculpture from different periods, you are likely

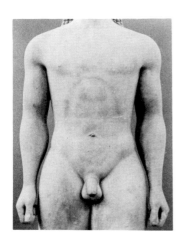

Kouros from Anavyssos. c. 520 B.C. Marble, height 76″. National Museum, Athens

to see more women than men. The reason, of course, is that most sculptors in the past were men, and most men love to create the bodies of women. However, periodically you will come across superb renditions of the male figure, which show that the sculptor had a great sense of his own maleness or was attracted to manly beauty.

If you open your eyes to cultures different from ours you can read into the forms of human figures what the sculptors themselves felt about maleness and how the people of their time reacted to what they saw. The Greek Kouroi of the sixth century B.C. may seem awkward at first brush, for they stand upright, usually with arms hanging down by their sides in a rigid pose. But if you look at their limbs, their muscles, the shape of their bodies, you will find them created with loving care. Certain parts of the body have especially powerful effects—the square shoulders, the powerful arms, the narrow waist and broad hips, the bulging pubic region blossoming into the fulsome genitals, the heavy thighs. Together they convey the essence of young, virile manhood. These are abstractions, and as you examine them closely you can see that liberties have been taken by the sculptor working in this tradition; but you can also see that the forms were designed to show off the male physiognomy in its most monumental and impressive form.

The later, more sophisticated male figures of the fifth, fourth, and third centuries B.C. are powerful in their own right, and overwhelming in the way in which they portray what strong and majestic male figures actually look like. Every part of their bodies seems perfectly formed. The great Artemision *Zeus* in Athens, his arms outstretched, is surely one of the grandest portrayals of the male physiognomy ever created. Later Greek male figures tend toward more feminine representations, but still every muscle is in the right place and clearly defined. The same is true of much of Roman sculpture, even those that are copies of early Greek works. Apparently the more feminine-looking

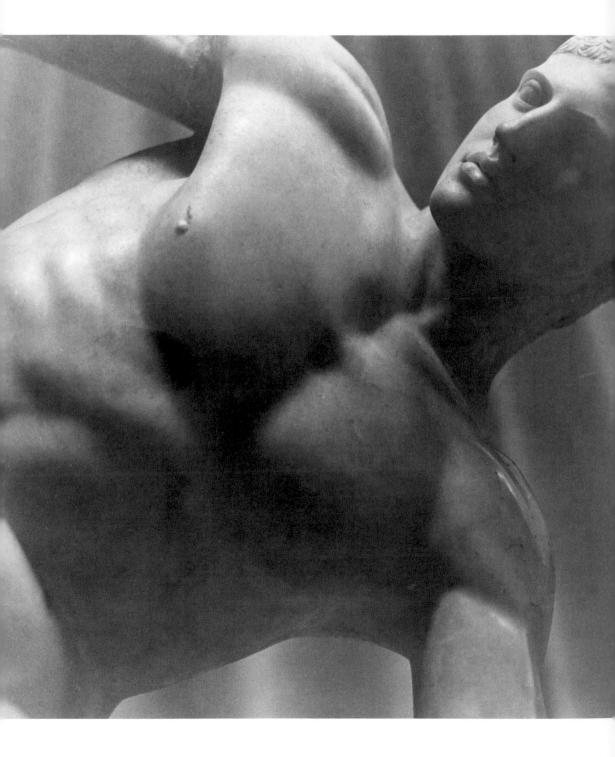

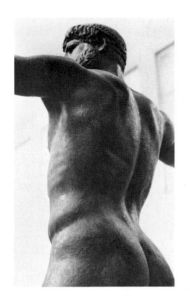

Zeus (detail) from Cape Artemision. c. 460–50 B.C. Bronze, height 82″. National Archeological Museum, Athens

Opposite: Myron. *Discus Thrower* (*Lancellotti Discobolus*, detail). Roman copy after Greek bronze original. c. 450 B.C. Marble, height 49″. Museo delle Terme, Rome

men who look as if they have the bodies of women appealed to Roman eyes. But this is not universally true. When we first saw the Roman copy of the *Discus Thrower* after the Greek sculptor Myron, who lived in the fifth century B.C. (the copy that is in the National Museum of Rome), my wife announced that he was her ideal of manhood. At first I didn't understand what she was talking about, because the image of the *Discus Thrower* in Greek sculpture was so familiar that I tended to look at the figure as a whole without examining the details; but when I looked more closely I could see what she meant. He certainly is a handsome young man—with broad chest, strong arms, and a grand physique, perfectly balanced.

The male was again revered and loved in Renaissance times, and this time the subjects were both Greek gods and Biblical heroes. Donatello's bronze *David* is almost embarrassingly frank as an expression of homosexual affection. It is not at all a virile figure in the spirit of the ancient Greeks; it is more like the Roman ideal of a young boy who might be the lover of an older man. Then came Michelangelo's *David*, the all-time beautiful male body. David was the patron saint of the city of Florence, which is why he was such a popular figure in Renaissance art. In the Old Testament story he was the great friend of Saul's son Jonathan, and when Jonathan died David was said to have mourned him more than any woman he ever loved in later life. This has apparently encouraged sculptors with a homosexual bent—as was the case with both Donatello and Michelangelo—to render their figures of David as a handsome youth who is magnificent in his nakedness.

Cellini, on the other hand, reverted to Greek mythology to find his ideal of manhood in his superb figure of *Perseus* in the Loggia dei Lanzi of the Piazza della Signoria in Florence. It would be hard to find a more perfect rendering of the young male body from every angle. I had the good fortune of being able to view the *Perseus* while stand-

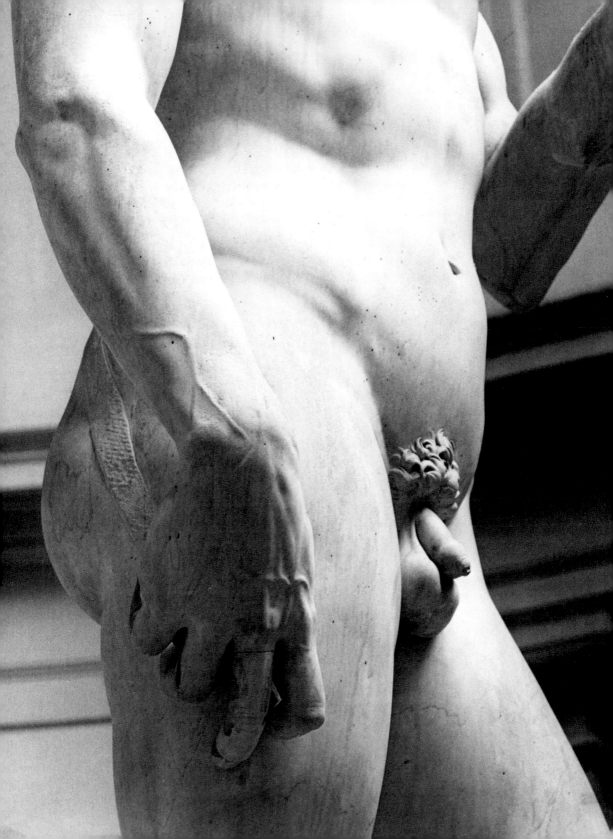

ing in a crane that lifted me high into the air and took me all around the sculpture so that I could photograph its details close-up; and I can confirm the proud boast in Cellini's autobiography about the miraculous achievement of the figure. It stands with remarkable grace; one arm holds the sword and the other the head of Medusa, his feet are balanced on the shield below, his head tilted triumphantly, and every muscle in his body shines as testimony to his glorious deed. His beautifully formed limbs make him the ideal—if not idol—of his time. Cellini, too, had homosexual as well as heterosexual liaisons, and his male and female figures are some of the loveliest ever created.

Donatello. *David*. c. 1440. Bronze, height 62¼". Museo Nazionale del Bargello, Florence

Right: Benvenuto Cellini. *Perseus*. c. 1545–54. Bronze, height 10′ 4″. Loggia dei Lanzi, Florence

Opposite: Michelangelo. *David* (detail). 1501–4. Marble, height 13′ 5″. Accademia di Belle Arti, Florence

Giambologna was also one of those who created his ideal male figure in his representations of the classical gods as with his *Mercury*. Here the twist of the body, which was one of Giambologna's hallmarks, enables the sculptor to show his mastery of muscles, bones, folds of flesh, as well as the graceful forms of the male body in motion.

Among the most beautiful male nudes are the figures of Christ that have been created by sculptors through the centuries. Christ is shown naked primarily on two occasions—when he is born and when he dies. Occasionally he is also shown naked when he has risen. The Christ child always reveals an era's ideal image of a baby and the dead Christ an era's ideal image of a man. Medieval figures emphasized the spiritual being; they may not be physically appealing to our eyes, but they can be extraordinarily moving as representations of great sorrow and suffering. On the other hand, Renaissance Christ-figures, both child and adult, are consistent with our image of beauty—a beautiful and happy child and a beautifully developed man with a perfectly formed physique.

The opportunity to create a magnificent body of the adult Christ was considered one of the highlights of a sculptor's career. Michelangelo carved five Christ figures. The first, and most youthful figure was the life-size Christ on the cross carved out of wood when Michelangelo was only a teenager. Now in the Casa Buonarotti in Florence, it is an exquisite work. There is the *Risen Christ* in Rome with its unfortunate girdle around the loins placed there by church authorities. Then there are the three *Pietà*s, which in a way represent the story of his life. The first and most famous was done when he was in his early twenties; the naked *Christ* was apparently an expression of his love of youth. In the second, which was intended for his own tomb but never finished, the figure of Christ suggests the inner torment the artist felt in his sixties. The final Christ, named the *Rondanini Pietà,* on which he worked until just a few days before he died at the age of eighty-nine, is an old

Above: Michelangelo. *Crucifix.* 1492–93. Painted wood, height 53″. Casa Buonarotti, Florence

Top: Giambologna. *Medici Mercury* (detail). 1580. Bronze, height 66¼″. Museo Nazionale del Bargello, Florence

man who has sunk into the decrepitude and tragedy of old age. Here the body of Christ is no longer the focus; it is his soul which one can almost see in the figure.

Donatello and Filippo Brunelleschi both created extraordinary Christ-figures in a sort of competition with each other. According to Giorgio Vasari, the leading art theoretician and artists' biographer of the sixteenth century, when the young Donatello carved his life-size, wooden Christ and proudly showed it to his friend Brunelleschi, the latter thought the figure had the body of a peasant. Donatello dared Brunelleschi to do better, and Brunelleschi took him up on it. When he finished his masterpiece, Donatello was so astonished that he dropped a basket of eggs that he was carrying.

Donatello's *Christ* can be seen in Santa Croce and Brunelleschi's in Santa Maria Novella, two of the major Florentine churches. It is interesting to go from one church to the other and compare the two figures. Donatello's *Christ* is a young, husky, strong-muscled, simple representation of the common man. Brunelleschi's figure is more graceful, more sophisticated, and more delicate, but oddly less powerful. As we look at these two wooden crucifixes today, we may feel a higher tension of form in the work by Donatello, who became the greatest sculptor of his time. Brunelleschi was an outstanding sculptor as well, but he won fame as the greatest architect of the age.

Another magnificent figure is the naked *Christ* carved by Cellini out of white marble, which is now in the Escorial in Spain. I had a strange experience in connection with this beautiful sculpture. Legend has it that when the sculpture arrived in Spain from Italy in the sixteenth century, the king of Spain, embarrassed by the nakedness of the figure, tied his scarf around its loins. Ever since, there has been a white cloth neatly tied around the figure. I arrived at the Escorial one day having obtained permission to photograph the *Christ* for a book on Cellini and was dutifully escorted inside the palace to the small church

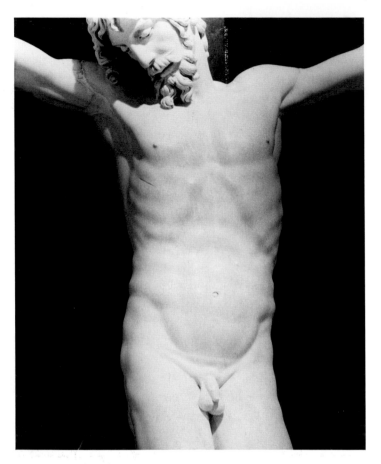

where it was mounted on one of the walls. When I saw the cloth around the figure's loins, I asked the attendant if it could be removed while I photographed it. He explained that special permission would have to be secured for that and this would involve tracking down the proper authorities in Madrid. I urged him to do so while I set up my equipment and started to photograph the piece. He left to make the inquiry, and another attendant was called in to stay with me while I worked.

About half an hour later a priest in workman's clothes came by with a dusting brush, cleaning everything in sight. When he came to the *Christ* he removed the cloth and dusted the whole figure. I was, of course, delighted

Above: Auguste Rodin. *Adam.* 1880. Bronze, height 75½". Musée du Louvre, Paris

Top: Antonio Canova. *Napoleon as Mars.* 1809. Bronze, 10' 6" × 4' 1". Palazzo di Brera, Milan

Opposite: Benvenuto Cellini. *Christ.* c. 1556–62. Marble, height of figure 56½". Monastery of San Lorenzo el Real, Escorial, Spain

and asked the priest if he would mind leaving the cloth off for a few minutes while I took some photographs. He quite willingly obliged, and I took several rolls of film to show the figure in all its glory. When I finished, he retied the cloth and went on his way with his dusting brush.

Subsequently, the original attendant returned, explaining that he had reached the proper authorities and unfortunately they could not give permission for the sculpture to be photographed in the nude. When he learned that I had already taken the photographs, he was furious. He wanted me to sign a paper stating that I would destroy the photographs taken without the loin cloth or "suffer the consequences!" A higher official told me that my film could be developed only by the authorities in Spain to be sure that the illegal negatives would be destroyed. I refused to relinquish my negatives, and it looked as if I would be arrested when my wife saved the day. She knew I had taken many rolls of film that I had safely put away, so why not take the remaining roll out of the camera and hand it over as if it were all the film I had taken? Acting as if I had finally yielded, I ceremoniously presented the film to my interrogator. He smiled triumphantly, and we were free to go.

Several weeks later I received the developed film with a couple of frames missing. Accompanying the roll was a bill for the cost of developing, which, of course, I never paid. When the photographs of the nude *Christ* were published in my book (as had been the case in previous books on Cellini), all agreed that it would have been unthinkable to have done otherwise. I'm sure that Cellini would have felt the same way.

Covering up genitals in sculpture has a long history. Michelangelo was furious when Pope Paul II decided that Christ's genitals in the *Last Judgment* had to be painted over; he refused to do so, and another artist was commissioned for the task. A girdle is still in place over the genitals of Michelangelo's sculpture of the *Risen Christ* in

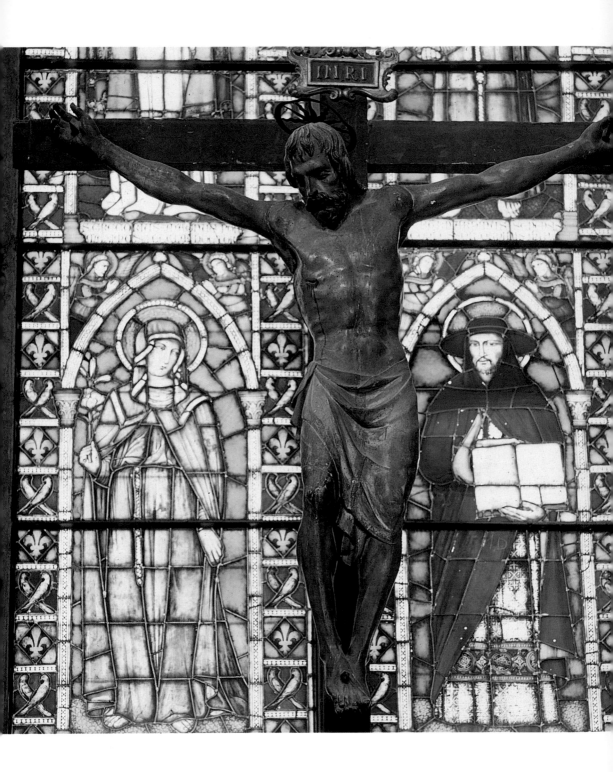

Santa Maria Sopra Minerva in Rome. When his *David* was installed in the Palazzo Vecchio in Florence, a string of fig leaves was, to his dismay, strung around the sculpture's loin, and when Queen Victoria visited the Victoria and Albert Museum to view the plaster cast of his *David,* a large fig leaf was made to cover it especially for her benefit. It was subsequently removed but still exists as a curiosity in one of the storerooms of the museum.

The point of all this is not that tastes change but that creating a representation of the naked body of Jesus was considered by sculptors an opportunity to represent the perfect male figure. Not to include the genitals in such a creation would be leaving out an essential element of his manhood. The scruples of more conservative authorities would mask the creation, but the intent of the sculptor in such instances is clear.

Sculptural renditions of male nudity appeared periodically in later centuries—with Bernini, Clodion, François Rude, Jean-Baptiste Carpeux, Antoine Bourdelle, and others. Canova's nude *Napoleon* transformed that short emperor into a giant god holding a statue of *Victory* in his hand. His physique in the sculpture is magnificent. The marble version is now located in the cramped stairwell of Apsley House (the Wellington Museum) in London, but there is a fine bronze cast in the courtyard in front of the National Museum (Plazzo Barberini) in Rome. He also did some plaster sketches for a nude *George Washington,* which can be seen in the Canova Museum in Possagno.

Rodin created a number of monumental male figures, including such sculptures as *Adam, St. John the Baptist,* and *The Thinker.* He had a remarkable facility for inventing poses that expressed the character of his subjects—a tilted shoulder, a dangling arm, an arched back, a tight fist tucked under a brooding chin. He was also a master of male musculature, and in his bronze sculptures one can feel the tensed body filled with energy. His stone carvings

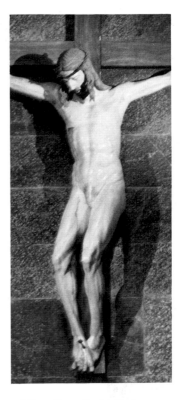

Filippo Brunelleschi. *Christ.* Mid-15th century. Painted wood, lifesize. Gondi Chapel, Santa Maria Novella, Florence

Opposite: Donatello. *Crucifix.* c. 1410–15. Polychromed wood, height 66⅛". Bardi da Vernio Chapel, Santa Croce, Florence

were extraordinarily delicate; even when they depicted a strong male figure, they had a subtlety of form that made them seem as if they were made of real flesh and blood.

A striking expression of masculine virility can be found in the twentieth century in Marino Marini's series of equestrian sculptures. A naked man on horseback became a symbol for Marini of the animal nature of human beings which he ennobled with his marvelous forms. Perhaps his idea was that a sexually aroused man can feel godlike, and many of Marini's riders have erect penises, with outstretched arms and heads thrown back as if in ecstasy. An equestrian sculpture that was owned by Peggy Guggenheim and was placed on her terrace facing the Grand Canal in Venice, had an erect penis that was removable to avoid embarrassing visiting priests. One of Marini's greatest sculptures shows the male figure leaning back horizontally while the horse's head soars mightily into the air like a giant phallus. (One cast is in the Museum of Modern Art in New York, while another is in the open court of a beautiful Renaissance building in Pistoia, Italy, where its magnificent forms are seen against the arches and stones of a religious edifice.) Called *The Miracle*, this sculpture is an expression of a seminal truth about the passions of sexuality and spirituality and their relationship to each other as part of the human experience.

Sculptures of women reveal an even broader range of tastes than do those of men. The prehistoric sculptor wanted his creations to be an active force in the process of conceiving and giving birth to offspring. Here the ideal woman was one with heavy breasts and a great belly. Sculpture was created to serve the highest of purposes; not only was it real in itself, but it was thought to have the power to affect those female functions most important to the future of the species. And when you look at those sculptures today, you can feel fertility in the forms.

The Egyptians and early Greeks were rather chaste about their female figures. Cycladic male and female

Marino Marini. *L'Angelo della città*. 1948. Bronze, 67¹¹/₁₆ × 41¾" (including base). Peggy Guggenheim Collection, Venice

Opposite: Auguste Rodin. *Despair* (detail). c. 1889. Marble, 13¾ × 23 × 17¼". The Saint Louis Art Museum

figures, for instance, are almost identical in their physiognomy. Indeed overt female nakedness took a back seat to its male counterpart in Western culture until later Greek and early Roman times. Initially the figures of women were made attractive by the drapery covering their bodies, the effect of which was sometimes more sensual than that of direct nudity. When women's clothes finally came off altogether, the Greeks (and their Roman copyists) produced some of the most beautiful women in the history of sculpture.

The *Aphrodite of Melos (Venus de Milo)* in the Louvre, the Capitoline *Venus* in the Capitoline Museum in Rome, and the Medici *Venus* in the Uffizi in Florence are superb examples of the Greek genius. However, my favorite female figures from Greek and Roman times are the *Aphrodite of Kyrene* and *The Dying Niobid,* both in the National

Aphrodite of Kyrene. Early 1st century B.C. Marble, height 56". Museo delle Terme, Rome

Right: *The Dying Niobid* (detail). c. 450–40 B.C. Marble, height 59". Museo delle Terme, Rome

Opposite: Marino Marini. *Miracolo*. 1952–53. Bronze, 85 × 73 × 54⅞". Palazzo del Commune, Pistoia

Museum in Rome. I remember falling in love with these two ethereal figures when I first saw them. I couldn't believe the delicacy of the way the breasts were carved, with such gentleness in the curves flowing out to the nipples, the soft flesh below the breasts swelling slightly around the belly and then curving back into the pubic area, the lovely thighs and the perfection of the legs, the beautiful backs and luscious buttocks: they were sculptures that were absolutely spellbinding. I went to see them again and again, and each time I found them more sensual than I believed possible. Even today I am thrilled when I find a lovely Greek female nude (usually a Roman copy) in a museum collection. It is a constant source of amazement to me that these classical sculptors were able to create such harmonious compositions in every part of the female anatomy.

It is impossible to discuss female beauty in sculpture without mentioning Eastern art, for the great Hindu tradition of sculpture led to the creation of some of the most extraordinary women in history. The idea of creating large, round breasts as grand expressions of femininity was clearly meant to express the ultimate in sensuality. Swelling stomachs and fulsome hips add to the voluptuousness of the figures. As one looks at these beautiful figures of goddesses, many of them with hands raised gracefully as if in tune with some lovely melody, one can almost hear music in the air. Those unfamiliar with sculptures from India, Thailand, and Burma may think they all look more or less the same, but if you look at them as works of art rather than stereotypes and examine the sculpture from different angles, concentrating your attention on the forms, you can recognize the greatness of the works just as easily as with Western art.

Among the greatest female figures in the Eastern tradition are the Khmer sculptures from the seventh to the tenth century. These are from the country now known as Kampuchea, and they can be found in a number of

Above: *Torso of Uma*. Angkor Wat Period, 12th century. Beige sandstone, height 22″. Doris Wiener Gallery, New York

Top: *Seated Parvati* (detail). 13th century, early Chola Style. Bronze. National Museum of India, New Delhi

Opposite: *Medici Venus*. Hellenistic Period. Marble, lifesize. Galleria degli Uffizi, Florence

museums and private collections. Both the male and the female figures are works of genius, but for me the female figures are among the most beautiful I have ever seen. Their round breasts have a softness and delicacy that are found nowhere else: the curves of the body in the midsection are exquisite, the shape of the sides, the drapery that inevitably folds around the hips, even the somewhat geometric forms of the back—all have an exceptional sensitivity of line and form.

Female sensuousness was not much of a factor in the work of medieval sculptors, and except for an occasional *Eve* there is not much to see. In religious scenes figures were clothed, and the beauty one can find is in the lavishness of the garments rather than in the flesh of the body. During the Renaissance, Donatello and Michelangelo each had trouble with the female nude. The only one I know by Donatello is a rather ungainly *Eve* in a relief on the altar of the St. Anthony Cathedral in Padua. Michelangelo's only female nudes (aside from his small bozzeto of a female *Victory*) are his *Dawn* and *Twilight* in the Medici Chapel in Florence; they are striking sculptures but definitely off-putting as women, with their odd-shaped breasts and masculine figures. It is not their bodies but their faces—with their haunting visions of inner soul as they look into an invisible space—that are magnificent. Ghiberti was one of the first Renaissance artists to appreciate feminine beauty, and he created two small but lovely nude representations of *Eve* in his *Gates of Paradise*. But it was not until the late Renaissance that sculptors once again dedicated themselves to the uninhibited joy of creating beautiful women.

Perhaps the most sensual girlish figure of the sixteenth century was the little sculpture of *Danae* by Cellini, in one of four figures in the niches underneath the *Perseus* (the originals are now in the Bargello Museum; the figures in the niche are casts). Just as Cellini managed to show all the muscles of his male figures to express his appreciation

of their masculinity, he found it possible to show every curve of a beautiful woman's body in this gorgeous *Danae*. If the Greek/Roman figures can be seen as ethereal, Cellini's *Danae* is lusty, if not lustful. It would be difficult to match the beauty of this marvelous figure. Although the sculpture is less than three feet high, it is a wonder to behold. The torso is truly magnificent, perfectly formed in every respect. The back of the figure is also remarkably beautiful even though it could not have been seen when it was standing in the niche. Cellini mentions in his autobiography that when he finished these four small figures and put them on a table in his studio, he considered leaving them as freestanding sculptures (as they now are in the Bargello), but he decided to put them in the niches since that was what they were created for.

If you look closely at the original bronze *Danae,* you will see how the breasts and the belly have been rubbed by appreciative viewers. These polished sculptures provide clear evidence that its special attributes appealed to lovers of women through the ages who knew that one way to appreciate a sculptural masterpiece is to feel its surfaces with exploring fingers.

Lest there be any doubt about Cellini's passions when creating his beautiful women, he proudly mentions in his autobiography that when he was working on his *Nymph of Fountainebleau,* he took time out every day to have sex with his beautiful model! This lovely lady achieved immortality in the relief that today is mounted high up on a wall in a large gallery of the Louvre. I found her especially appealing when I looked at her from the right side, while standing on a grand stairway near the sculpture, which proves that relief sculptures as well as sculptures in the round deserve to be looked at from different angles.

Giambologna was another sixteenth-century sculptor who delighted in sculpting beautiful women. His perfectly formed figures are masterpieces of design as well as of femininity. Their arms and legs interweave to form strik-

Giambologna. *Venus of the Grotticella.* c. 1570. Marble, height 51″. Boboli Gardens, Grotto of Buontalenti, Florence

ing patterns in space, their heads are regally posed, their hands and feet are always elegantly positioned. As one looks in and out and up and around his women, one cannot fail to be impressed by the way he made their bodies fit into complex compositions of three-dimensional harmony.

The only problem with Giambologna's women is that they lack personality. Their faces are blank, the look in their eyes distant, their mouths expressionless. They appear indifferent to the glorious shapes the sculptor has given their bodies. This can be disconcerting to the viewer who wants to feel some contact with the being inside the stone; but there is no question about the magnificent anatomy of their figures.

One of Giambologna's finest nude figures is the *Venus of the Grotticella* in a grotto in the Boboli Gardens behind the Pitti Palace in Florence. The gates on the grotto are usually locked and one needs permission to go inside, but it is definitely worth doing so. This beautifully formed woman in white marble stands in a marvelous pose in the center of a painted room, and as you walk around the sculpture it is her rear view that is especially stunning. Every line in her body is a delight to see; standing quietly in her magnificent setting she is one of the gems of the late Renaissance.

It is intriguing to discover the different character of sculptured female nudes through the centuries. In the eighteenth century, George Raphael Donner created luscious nudes for the fountains of Vienna. One of my favorite eighteenth-century sculptors is Clodion (Claude Michel), and while his small terra-cotta figures do not have the monumentality of Cellini's or Giambologna's masterpieces, they do have a unique charm. Clodion's young women seem to be made for love, and they are almost always sporting around with handsome, eager men. Their arms and shoulders are often tilted to show their petite breasts and rounded stomachs to best advantage. They have lovely bodies and always seem to be

Benvenuto Cellini. *Danäe with the Child Perseus* (detail). c. 1545–54. Bronze, height 32⅖". Museo Nazionale, Florence

Opposite: Benvenuto Cellini. *The Nymph of Fontainebleau* (detail). c. 1543. Bronze, 6′ 6⅗″ × 13′ ⅕″. Musée du Louvre, Paris

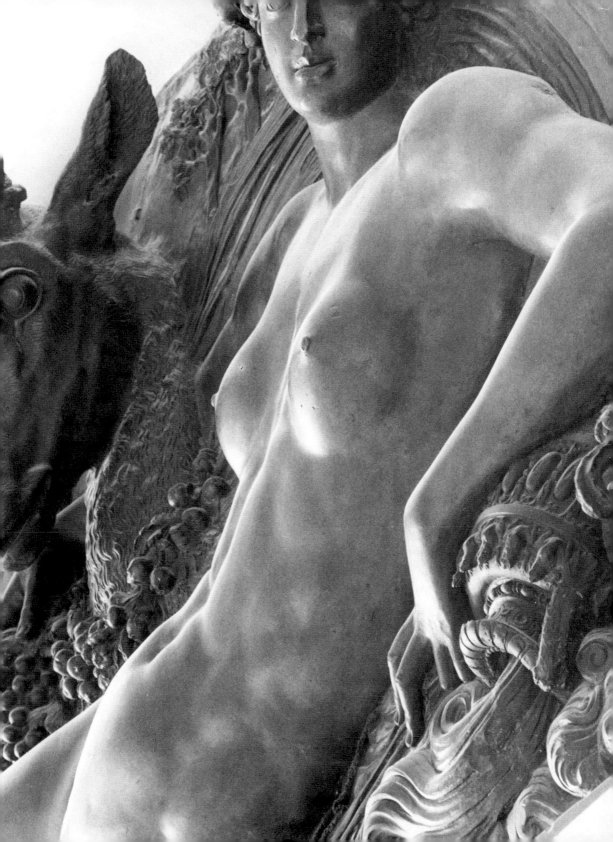

enjoying their nakedness. Particularly appealing in these small sculptures is the fact that their faces are as delightful as their bodies. With or without clothes these charming young women would turn the eye of any young man passing by. The Clodion sculptures in the Vatican exhibition that traveled around the United States in 1985 were among the most popular works in the collection.

Canova was one of the all-time masters of womanly beauty. It is amazing to me that most art historians of recent times have considered his work to be cold, as I consider them to be incredibly sensual. I admit that there is a sort of icy disdain in the stance of some of Canova's regal figures, which seem unearthly in the way they hold their bodies and look out into space. But if one examines the "fleshy" part of any of his nude figures, the impact is totally captivating.

It is difficult to describe the glory of Canova's rendition of flesh. He seems to have invented a special form of poetry with his sculptor's tools. Every line of the body plays a part in the process, as does every movement of the light over the forms, every crease, every curve of flesh. And the folds of garments as they gently flow around the figures are created with equal tenderness, each passage a marvel to behold.

In Canova's lifetime he was considered the greatest artist who ever lived, but his neoclassicism became a subject of scorn in the twentieth century. Many of the masterpieces that had been revered in his time were relegated to storerooms, his works thought to be typical of an age that had gone overboard in sentimentality and sweetness. But if you look at the naked bodies of Canova's figures, particularly his women, you will come to an entirely different conclusion. Whenever my photographs of details of Canova's nudes have appeared in magazines or books, readers were convinced that they were a photographer's revelation of the ravishing parts of a live nude model rather than a marble sculpture.

Clodion (Claude Michel). *Cupid and Psyche* (detail). c. 1780–90. Terracotta, height 23⅕″. Victoria and Albert Museum, London

Some of Canova's women such as *Hebe* and *Psyche* are barebreasted but draped below. Even in these sculptures one can find spellbinding qualities at every turn. Not only are there beautiful shoulders, breasts, and backs, but the arms, legs, fingers, and toes are delicately wrought, the facial features are extremely sensitive, and the pose of the figures is finely balanced. The *Venus* he did to replace the Capitoline *Venus* taken by Napoleon to Paris is marvelous, as is the other version now in Leeds, particularly in the way the fingers of one hand gently touch a breast. The sensuality of every inch can take one's breath away.

Certainly one of Canova's greatest masterpieces is his *Three Graces*, which now can be seen in Woburn Abbey in England and was one of the main attractions of the exhibition of "The Treasure Houses of Britain" at the National Gallery of Art in Washington, D.C. In its permanent location a lovely soft light washes over the sculpture with a gentleness that brings out its greatest qualities, but in the Washington exhibition the spotlights provided too many contrasts and hid some of the most revealing parts in deep shadows. For this is one sculpture that can be appreciated equally in every one of its parts, from head to toe of each figure—front, back, side, and everything in between. The three naked women in different positions show what is beautiful in all aspects of a woman's body. And their interrelationship is ingeniously conceived. When a very large photograph I took of the legs of all three women as seen from the side—a view that is rarely seen—was once exhibited, viewers thought it was actually taken of three nude women whose legs were intertwined in loving embrace.

This achievement of sculptured nudity is somewhat surprising when one realizes that Canova's own sexual interests were somewhat uncertain. All that seems to be known about him was that he was once engaged to be married, but the engagement was broken off, and he was never known to have had any other relationships with

Right. Antonio Canova. *The Hope Venus* (detail). 1817–20. Marble, height 69⅝″. City Art Gallery, Leeds, England

Opposite: Antonio Canova. *Three Graces* (detail). 1815–17. Marble, height 65⅝″. Duke of Bedford, Woburn Abbey, Buckinghamshire, England

women or with men during his life. In that respect he was the opposite of Cellini, who relished every kind of sexual adventure in which he could engage. Once, when admiring Canova's reclining nude woman in the Victoria and Albert Museum in London, I asked the keeper of sculpture if he thought someone who didn't love a woman's body could possibly have produced this work. He didn't, and I didn't either. I later thought of a passage in the autobiography of Havelock Ellis, the great authority on sexual mores in different cultures, in which he described a conversation with a woman who seemed especially inspired by his writings. When he explained that he was one of those individuals in life who was more of an observer than a participant, she expressed amazement that he could have written so passionately and intimately about sexual experiences. His point of view was that "it is the spectator who sees most of the game," and that his

Right: Antonio Canova. *Three Graces* (detail).

Opposite: Per Hasselberg. *The Snow Drop*. 1885. Marble, height 63″. Konstmuseet, Göteborg, Sweden

experience had been "ample enough." Perhaps this was true of Canova as well.

The nineteenth century saw many followers of Canova commit to stone their love of naked beauty. The Danish sculptor Bertel Thorvaldsen was perhaps the most famous, and his figures have their own outstanding quality, although to my eyes they are not quite up to Canova's level. Hiram Powers, an American who studied in Italy, produced one sculpture which became legendary. Called *The Greek Slave*, it was toured around the United States in exhibitions that men and women had to visit separately. Powers carved many versions of this work; one can be seen

97

today in the Corcoran Gallery of Art in Washington, D.C., and another in The Brooklyn Museum.

Per Hasselberg. *The Snow Drop* (details)

Many other artists during this period created beautiful women, but their works are not generally known. I came across one such sculptor in the unlikely place of Gothenberg, Sweden. In the center of a large gallery, I found a magnificent young lady in white marble, completely naked except for a wisp of a cloth around her waist. Her pose was somewhere between languor and ecstasy. She had a lovely face, with eyes closed, one hand reached up to run her fingers through her hair and the other held the curious cloth around her waist. Her body seemed to be shifting its weight from side to side, her hips curving, her lovely limbs slightly bent in an exquisite manner. I walked all around the sculpture as I always do and found that it was just as beautiful from every side; so much so that I literally could not believe my eyes. This was not a Canova creation; it seemed like a real, living girl, a beauty

of the ages who the sculptor had magically carved into marble. So wonderful was she that I took advantage of being the only one in the gallery at the time and reached up to touch her (she was standing on a rather high pedestal) to assure myself that the quality of the surface was as fine as it looked. It was!

The artist was Per Hasselberg, who, as I later found out, was a Swedish sculptor of the late nineteenth century who had studied in Paris. Several other major marble sculptures by Hasselberg were also in the museum. One was a young naked woman lying in a most erotic position—legs apart, again eyes closed, arms stretched out—apparently in sexual ecstasy; the sculptural quality was not quite up to that of his standing figure, but it was still an amazing work to look at. Another was a naked woman crouching on her knees, looking out—again seemingly an actual portrait of a very beautiful Swedish girl.

Nakedness continued to fascinate sculptors at the turn of the century. Aristide Maillol's famous bronze nudes were substantial, full-breasted women with broad hips, round buttocks, and heavy thighs who proudly flaunted their attributes. The positions of his women—some with shoulders, back, and breasts exposed, another bent over with buttocks in the air—were in themselves expressions

Per Hasselberg. *The Water Lily* (detail). 1890. Marble, length 64". Konstmuseet, Göteborg, Sweden

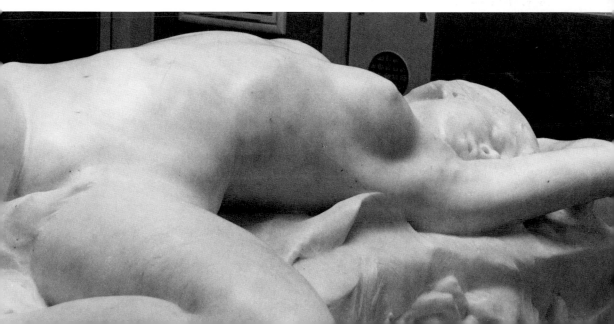

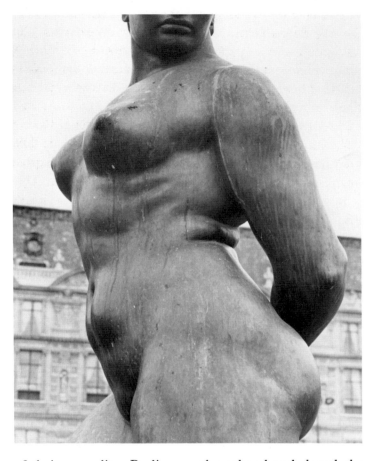

Left: Aristide Maillol. *Action Unchained.* 1906. Bronze, 83¾ × 41 x 37½″. Musée du Louvre, Paris

Opposite, above: Henry Moore. *Woman.* 1957–58. Bronze, height 60″. Forte di Belvedere, Florence

Opposite, below: Gaston Lachaise. *Seated Torso.* 1928. Bronze, height 9″. Private Collection, New York

Overleaf, left: Antonio Canova. *Cupid and Psyche.* 1787–93. Marble, 61 × 66⅛″. Musée du Louvre, Paris

Overleaf, right: Auguste Rodin. *Hand of God.* 1898. Plaster, 28¾ × 25 × 26″. B. G. Cantor Collections, New York

of their sexuality. Rodin, on the other hand, loved the gentleness of the female figure and showed her softly, even passively in the midst of her eroticism as she emerged from the stillness of the marble. Neither Rodin nor Maillol was concerned about representing specific women or representatives of mythical or biblical figures. They were just women for women's sake.

An American sculptor, Gaston Lachaise, created female figures with enormous breasts, broad hips, even enlarged sexual organs, all of which seem to arise out of the primeval feelings that are expressed in tribal art. They are intended to convey a compelling sense of those womanly attributes which arouse men's passions.

This chapter cannot end without some reference to the theme of naked lovers. Canova created several of these, the most famous being *Cupid and Psyche* in the Louvre. This is a tender representation of a loving encounter that is almost chaste. There is no frank sexuality here, no aroused emotions, just tenderness and affection of the most exalted nature. Even Cupid's arm around the breasts of Psyche looks angelic rather than passionate. It shows godlike love more than human love, but it has all of Canova's great qualities as a master of delicacy and intricate form.

Rodin's lovers, on the other hand, are flesh and blood. *The Kiss* has become such a cliché through overexposure that one almost forgets to look at it as sculpture, but its depiction of a man and a woman in a loving encounter is far more passionate than Canova's work. Rodin created other lovers that are even more sensual. *The Hand of God*, for instance, shows two figures barely discernible in the great hand of God, thereby presenting sexual love as a religious experience. Rodin created many variations of lovers, including, as mentioned above, women making love to each other, one of his favorite themes.

One sculptor in the twentieth century made the subject of loving embrace his life's work. Gustav Vigeland filled an entire park in Oslo with hundreds of figures in what he called *The Cycle of Life*. In his youth he created daring sculptures of figures bound together in sexual union. In the park he showed men and women in an amazing variety of passionate relationships, holding each other in almost every conceivable romantic position. He also showed old men and women together as well as boys and girls, and even babies playing with each other. He showed mothers and children, fathers and children, grandparents and children. He even showed men and women with animals. And all his figures are naked in what appears to be a fantastic orgy of human love that is unique in the history of art.

Vigeland worked in plaster, wood, bronze, stone, and even created iron gates for the entranceway to the park.

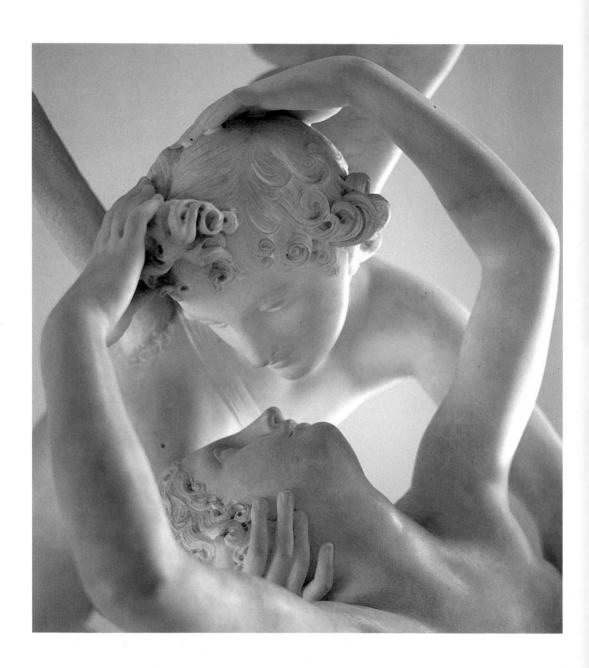

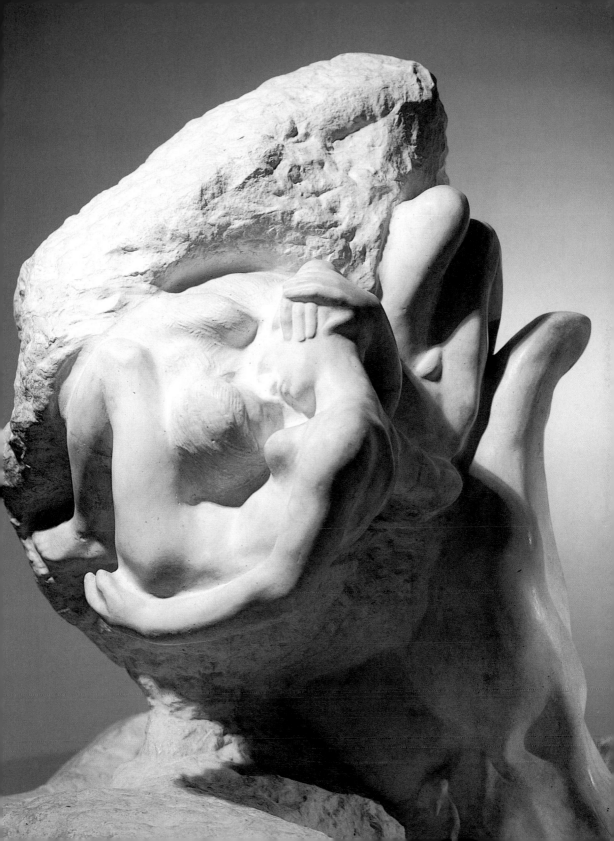

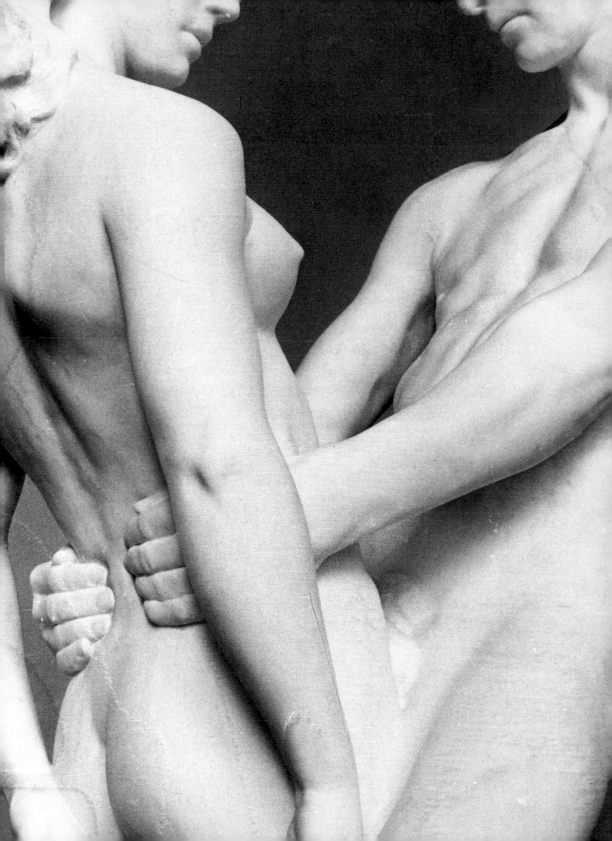

George Segal. *Picasso's Chair* (detail). 1973. Plaster, wood, cloth, rubber, and string, 79 × 60 × 32″. The Solomon R. Guggenheim Museum, New York. Gift of Dr. Milton D. Ratner

Right: Gustav Vigeland. *Untitled* from *The Cycle of Life*. 1930s. Plaster, lifesize. The Vigeland Museum, Oslo, Norway

Opposite: Gustav Vigeland. *Untitled* from *The Cycle of Life*. c. 1912. Marble, lifesize. The Vigeland Museum, Oslo, Norway

His figures do not stand up to close scrutiny from all angles and in all details, but one can almost always find some views of his embracing figures that express the full range of the most tender to the most intense love people can feel toward each other.

Naked men, women, and lovers are still being produced by sculptors in our time, but that is not where the center of the sculptural world is today. Our era has become absorbed in different sculptural ideas and forms. Even George Segal's spectral plaster figures, cast from live models, are not created to show the sensual beauty of the human body, but rather to mix reality and unreality in new and jarring ways that make us think differently about life in our time. To appreciate one of the most persistent and powerful strains of sculpture from ancient times until our own, we have to recognize the importance of naked beauty in the artist's eye and mind and heart and hand over the long expanse of history, for that surely has been one of the sculptor's primary obsessions.

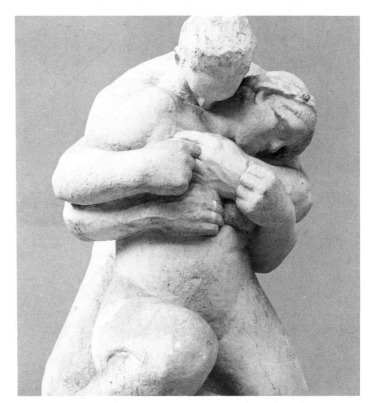

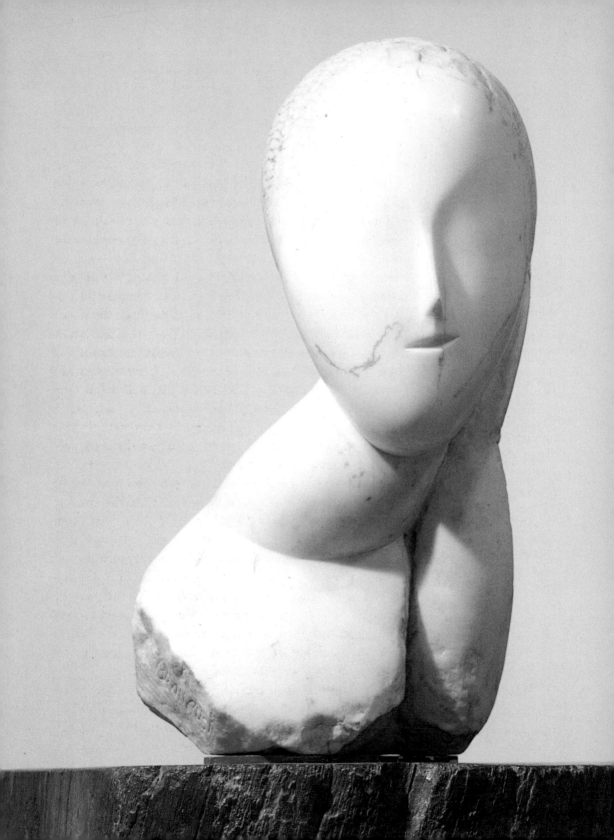

THE MATERIAL TRUTH—
AND BEYOND

I n the early twentieth century something happened to change the direction in which sculpture had been going almost throughout recorded history. It paralleled the transformations in the art of painting, yet in a way the changes were even more dramatic in sculpture that had relied so heavily on the human figure as its source of inspiration.

Young artists of the early twentieth century could not outdo their masters in verisimilitude to the human figure, so they broke new ground by departing from the naturalistic representation that characterized the late nineteenth century. Rodin, one of the titans in the history of sculpture, paved the way with increasingly expressionistic forms. But it was Brancusi and his followers who were responsible for the major revolution that took place shortly after the turn of the century. The key to their new outlook was the importance they placed on the materials they were using. Stone now had to look like stone (rather than flesh or clothing or furniture as had been common in the nineteenth century), wood like wood, metal like metal. There would no longer be an effort to "deceive" or "trick the eye." Integrity was the byword now, and the goal was to make the most of each material in creating new forms.

The objects that emerged as a product of this philosophy were often not easily recognizable. In his early years, Brancusi carved very sensitive but simple representations of the human figure. Then, as he developed his idea of finding the essence of the material he was using, he created abstract shapes such as *Bird in Space*. Nothing in this bronze sculpture resembles a bird, but its curving, glistening shape is as beautiful as any flight path a bird might take while soaring into space. A polished bronze ovoid entitled *Sleeping Muse II* that is intended to represent a

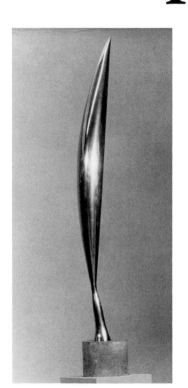

Constantin Brancusi. *Bird in Space (L'Oiseau dans l'espace)*. 1932–40. Polished brass, height 53″. Peggy Guggenheim Collection, Venice. The Solomon R. Guggenheim Foundation

Opposite: Constantin Brancusi. *The Muse (La Muse)*. 1912. Marble, 17½ × 9½ × 8″. The Solomon R. Guggenheim Museum, New York

head scarcely has a hint of facial features, but it has a magically captivating feeling about it. In wood, he created a *Philosopher* that seems to express the search for values of substance, as solid and sound as the wood texture of the work. In another sculpture, a beautiful head of white marble is mounted on a heavy, rough wood which looks like a rare precious object made of the finest materials. His idea was that if one were true to the material being carved or cast, the sculpture would find its own voice with which to convey its poetic message to viewers.

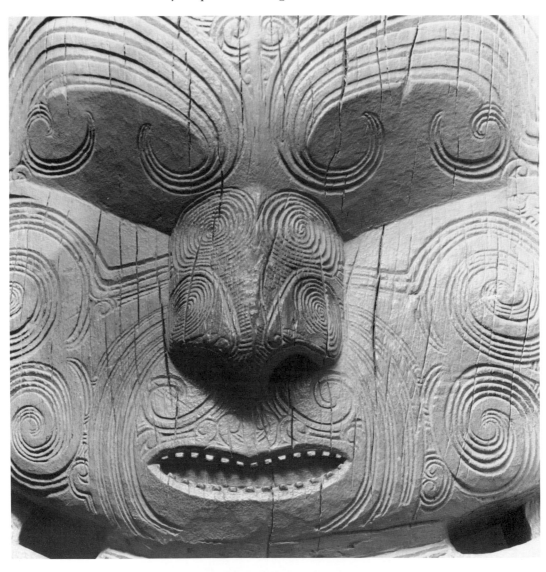

The forms created by Brancusi were inspired by objects he saw in the world around him such as rustic wine presses which were common in his native Romania. Brancusi and other sculptors who share his reverence for materials recognized the simple honesty in the way primitive and peasant artists approached their materials. They valued stone or bronze or wood for themselves.

Brancusi's simple, unrecognizable forms can sear one's soul in their purity. They seem in their utter simplicity as close to perfection as an artist can get. Wood or stone or polished bronze has rarely looked quite as marvelous as in his sculptures.

The revolution initiated by Brancusi led to Modigliani's great stone heads and caryatids, Picasso's playful assemblages, the geometric forms of Jacques Lipchitz and Laurens, the monumental carvings of Jacob Epstein, the inventions of Gaudier-Bzreska, the earthy creations of Henry Moore. All are manifestations of the passion for the material that was being used in the sculpture. These sculptors seemed to think they had discovered beings inside the stone, wood, or metal, and their forms gave life to those beings.

African and Oceanic carvings were greatly admired by the new generation of sculptors. It was thought that tribal art was untainted by the sophisticated technique of the classical, neoclassical, and baroque sculptures of previous centuries. There was a freshness and directness about these comparatively simple creations that seemed to point the way to a new aesthetic. The savage, untutored expression of the simple truths of life had great meaning for the sculptors who were leading the way of the civilized world of the early twentieth century. They were thrilled to discover that the essential qualities which make a sculpture great could be found in those primitive, usually anonymous objects just as readily as in the works of the famous artists of western culture: the same extraordinary interweaving of forms, the same changing harmonies as one

Te Ngae Gateway Figure from Rotorua. Early 19th century. Wood, height 77⅛". Mr. Justice Gilles, Auckland Museum, New Zealand

looks at them from different angles, the same quality of genius in the way forms and spaces interrelate, the same fascination with details. But they also seem to possess a magical power, as if those creations could affect the lives of the people for whom they were created—which was, of course, their intention.

One particularly powerful rendition of an Austral Island god fascinated Picasso. Carved out of wood, it had a monumental form, standing with its hands on a swollen body, and was covered with small figures of humans apparently emerging from the skin. Even the nose, eyes, and mouth were in the form of these little figures, and others clamored all over its front and back. Picasso apparently saw it in the British Museum and arranged to have a bronze cast made for himself (perhaps a curious contradiction of the idea of truth to materials since a form made in wood would lose something by being reproduced in bronze; nevertheless, it was the only way Picasso could have the sculpture for himself). Some fifty years later the architect Gordon Bunschaft remembered seeing this sculpture in Picasso's home. He managed to locate the molds at the British Museum from which the cast was made, and told Henry Moore, who also loved this particular piece, about his discovery. Arrangements were made for two new casts to be made. When Moore put his cast in his home in Much Hadham, he was astonished at the power of the sculpture and said he had a hard time finding a place for it in which it would not overwhelm the other works he kept around him.

About that time I was working with Moore on a book about his favorite sculpture in the British Museum, and I had a wonderful time photographing all the little figures I found on the body of the god. Moore thought my photographs captured the essence of the sculpture, and he remarked that "the little images, scattered all over the body like frogs jumping from a pool, are not stuck on but are all part of the same piece of wood—a remarkable

The God A'a from Rurutu, Austral Islands. Wood, height 45⅗". British Museum, London

technical achievement. And each figure is a separate piece of invention. The excitement of this piece comes from its sense of life-force, with all those small figures springing from the parent figure. The head, too, is marvelous. Its great round back repeats the shape of the full, round belly, but emphasizes, by contrast, the thinness and sharpness of the jaw." As far as he was concerned, this sculpture could hold its own among the finest works in the British Museum.

Not only the monumental forms of these primitive works but the simple honesty in the way human emotions were represented were a source of inspiration to the new generation of European artists. A god created men and women out of his own body. A mother held her child with animal-like love and protection. Men were warriors, hunters, builders, and they showed intense emotions of anger, fear, awe. The new sculptors were inspired by the "truth" found in the work of these tribal masters. As a result, there was a freshness in their portrayal of a face, or the stance of a figure, or the shape of an animal.

The simplified forms of the twentieth century, stimulated by the rediscoveries in primitive art, led to the expressions of ideas in a newly invented, symbolic language. Jacob Epstein, for instance, created two doves, one sitting on top of another, to portray the physical experience of the sexual act, and he thought that the beautifully simple lines of the doves produced a stronger emotional impact than a literal portrayal of a human embrace. Jaques Lipchitz created two figures that look like a cross between turtles and humans as they clutch each other in sexual ecstasy. Somehow the inner experience of beings was manifested in these new forms being invented by sculptors.

This new approach to sculpture led to the ennobling of the human figure in original ways. Some of the finest representations in this spirit were created by Wilhelm Lehmbruck, a young German sculptor who committed

Jacob Epstein. *Doves.* 1913. Marble, length 18³⁄₁₀″. Tate Gallery, London

suicide at the age of thirty-eight just after World War I. He believed that "every work of art must retain something from the first days of creation, something of the smell of earth, or one could even say: something animate.... Sculpture is the essence of things, the essence of nature, that which is eternally human." Among his greatest works is a larger-than-life *Kneeling Woman,* which is one of the most tender sculptures ever created. The Museum of Modern Art in New York has a cast stone version of this work together with another Lehmbruck figure of a *Rising Youth,* which seems a perfect counterpart.

Lehmbruck's work had a profound effect on me as a young man; the two figures at the Museum of Modern Art were among my favorite works. Then when I was about eighteen, I happened to come across a terra-cotta head of a woman by Lehmbruck in the Otto Gerson Gallery in New York, and I fell madly in love with it. Created about a year or so before the *Kneeling Woman,* it had the same wistful expression, the same tilted posture, the same tenderness. In a burst of youthful enthusiasm I introduced myself to Mr. Gerson and confessed that my dream in life was one day to own that sculpture. He smiled at my fantasy and told me that since he loved the sculpture as much as I did he would never part with it. But he invited me to come to his gallery whenever I wanted to have a cup of coffee and enjoy looking at the sculpture we both loved so passionately. I went to see him frequently to look at this marvelous work, and the more I saw it the more I loved its tender beauty.

Years later, Otto Gerson died, and his collection was acquired by the Marlborough Gallery. One day I was taken through the storeroom of the gallery on another mission, and there, to my astonishment, sitting on a shelf was my Lehmbruck head. This time, I was able to realize my dream, and since my wife shared my feelings, it became one of our most prized possessions. When we brought it home I told my children that my heart was in

Wilhelm Lehmbruck. *Kneeling Woman.* 1910. Terracotta, height 16½". Private Collection

the sculpture, and that if anyone should break it by mistake it would break my heart. They believed my heart actually *was* in the sculpture and they acted most reverently toward it, which I found to be quite appropriate for my beloved treasure.

The sculptor who emerged as the dominant figure in the twentieth century was Henry Moore. He was both the child of the Renaissance, with Michelangelo as his ideal, and a devotee of primitive and medieval art. His personal treasures in his home included a collection of Cycladic sculpture, a number of excellent African and Oceanic sculptures, several Rodin sculptures, a great stone carving from a medieval church, an ancient sculpture of a lynx, and a miscellany of stones he had picked up in his travels,

Henry Moore. *Sheep Piece*. 1972.
Bronze, height 14'6". Hoglands,
Much Hadham, England

including one found in the Carrara caves that he was sure had once been held by Michelangelo. These were among the sources of his inspiration, and out of them he created what became the archetypal sculptural forms of his time.

Moore's sculptures are mysterious. There is no way to explain what they mean; it is even uncertain that Moore had something definite in his mind when he created his forms. He worked instinctively, starting from some idea he might have found in a bone or a stone or out of his head as he experimented with his small maquettes. He sometimes gave different explanations for the same sculpture, almost as if they were ideas that occurred to him *after* he produced his work. For instance, he called one of his sculptures *Boat Form* when he first produced it as a maquette and it was placed on its back like a rowboat. Later he decided to stand it upright and called it *Totem Head*. Others believe it to be an abstract conception of the female sexual organ and speculate that the quiet-spoken and reserved Yorkshireman would have been embarrassed to give it a name that was more accurate. He once said that he created his famous *Sheep Piece* as a "gift to the sheep" in a meadow near his studio that he used to watch rub their backs against tree trunks. He made his giant sculpture so that the sheep could rest in its shade and rub themselves against its curving interior surfaces. When an art historian later wrote that the sculpture represented one sheep mounting another, Moore told me rather shyly, "I guess you can read anything you want into it."

Moore had certain themes that preoccupied him—the reclining figure, mother and child, the family group; but each sculpture was an individual creation. In a sense these works were like Raphael's madonnas, Rembrandt's rabbis, Cézanne's apples, Van Gogh's flowers. Great artists had their obsessions, subjects they found endlessly fascinating, but the secret of their greatness lay in what they did with those subjects not in the subjects themselves.

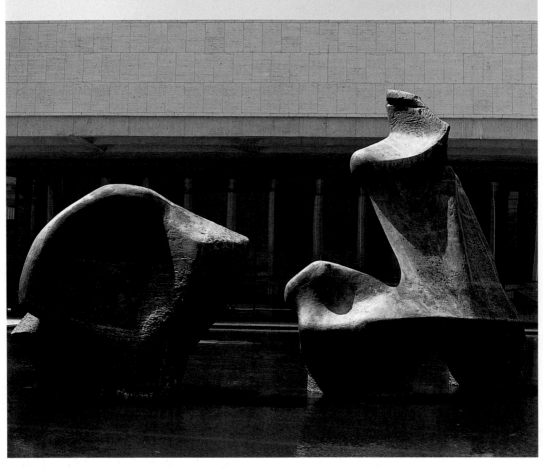

When Moore first developed his enigmatic forms they were greeted with horror and dismay. A famous incident involving the purchase of a Moore sculpture by the city of Toronto for its new City Hall illustrates how intense those emotions were. The mayor of Toronto took a leading part in bringing the sculpture to the city and was especially proud of his achievement. But his sense of accomplishment was not shared by the electorate. Shortly after the sculpture was installed he lost his re-election bid, and his political defeat was attributed by analysts to his support of the Moore sculpture. Years later the city of Toronto

Henry Moore. *Reclining Figure.* 1963–65. Bronze, length 30′. Lincoln Center, New York

Opposite: Henry Moore. *King and Queen.* 1952–53. Bronze, height 64½″. Glenkiln, Shawhead, Dumfriesshire, Scotland

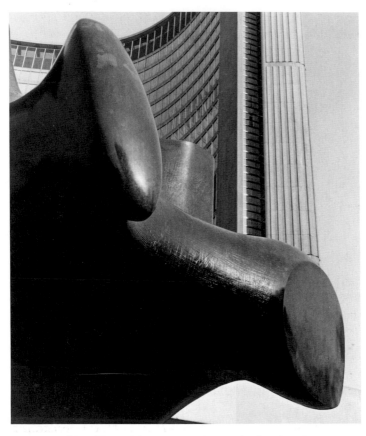

Henry Moore. *The Archer.*
1964–65. Bronze, length 10′8″.
Nathan Phillips Square, Toronto

redeemed itself, and in a great show of affection for Moore created a Henry Moore Museum in its Gallery of Modern Art, which today houses the largest collection of Moore plasters in the world.

In time Moore's work became admired and beloved, sought after all over the world. There is something glorious in the way his forms writhe around each other; the way the air seems to pulsate in the spaces he created; the remarkable inventiveness that made each sculpture a combination of forms never seen before; the tension in the surfaces as they swoop and sweep up and around; the ever graceful lines that one's eye can discover as one explores the bulges and cavities; the way the light falls on the forms, creating delicate shadings in some areas and

monumental abstractions in others; the intriguing textures that appear sometimes like scratches, sometimes squiggles, sometimes gouged cuts, sometimes heavily lined elephant-like skin, sometimes rocklike formations, sometimes machine-like surfaces; the colors of a patina that looks as if it has aged for centuries, or of a polished bronze that shines like a golden jewel; the surprise of different shapes and forms appearing out of nowhere as one looks at the sculpture from different angles. Each sculpture is an encyclopedia of aesthetic experiences. One can look at it endlessly and always find something new to appreciate. This alone seems a measure of his greatness: indeed Moore's work makes us wonder if the greatness of any sculpture may be measured by the number of spellbinding discoveries one can make in it. Moore would probably like that idea. I think he would agree if I suggested Michelangelo's *Rondanini Pietà* as the ultimate example of a sculpture in which an infinite number of discoveries could be made, and he would be very pleased if I suggested that his great *Reclining Figure* at Lincoln Center also achieved that ideal greatness, which in fact is what I feel.

Moore was not the only sculptor to refuse to explain what his forms meant; for many artists a sense of mystery was central to the adventure into unknown realms. I once asked Marino Marini the meaning of two rather abstract forms on the back of a sculpture called *Il Guerrero*. When my wife and I first saw it, we thought they looked like two figures locked in an embrace, but when I read somewhere that the sculpture represented a mortally wounded soldier and that it was an expression of Marini's fear that nuclear weapons could bring about the end of mankind, I thought perhaps the two forms represented the broken body of the warrior. Marini laughed at my question. "That is the trouble with you northerners," he said. "You want an explanation of everything." He insisted that he had no idea what they meant. They were just there. The

Left: Marino Marini. *Seated Woman*. Date unknown. Painted plaster, height 12″. Collection Marina Marini

Opposite: Alexander Calder. *The Door*. 1968. Painted metal, 53 × 29″. Weintraub Gallery, New York

sculpture was its own meaning. When I told him that Moore had given me similar answers when I asked him about his sculptures, Marini nodded knowingly and said, "Moore is a northerner reaching to the south, and I am a southerner reaching to the north. We meet somewhere in between."

As with Moore, certain themes fascinated Marini—the horse and rider, the circus acrobat, the goddess Pomona—yet each sculpture is unique. They are not variations on a theme but individual expressions that stand on their own as manifestations of Marini's extraordinary ability to create monumental forms. His early bronze sculptures have an earthy grace that makes them some of the finest

humanistic sculptures of our time, his late works a monumentality resembling carvings on ancient stones.

Marini started out in life as a painter and was always intrigued with the color of his sculpture. Some of the works were actually painted in lively colors that added a sparkle to the forms; others had remarkable variations in the patina, with gold textures of the raw bronze showing through the rocklike colors that were his specialty. All his sculptures—whether they be of the horse as the ultimate symbol of nature's nobility, the playful antics of the acrobat, or the voluptuous richness of female flesh—show an immense love of life. When my wife and I were fortunate enough to acquire a particularly luscious *Pomona,* my mother-in-law couldn't understand why we wanted a sculpture of a "fat woman" in our home. My wife explained that Marini's sculpture taught her what could be beautiful about a woman with a fulsome figure.

As Moore was developing the body of work that was to make England the center of the sculptural world in the twentieth century and Marini was becoming a major force in an Italian sculptural renaissance, the Swiss sculptor Alberto Giacometti made his mark by inventing his extraordinary elongated figures, and the Spanish sculptor Julio González discovered the beauty of welded steel. The latter proved to be particularly significant as the search for new forms and new ideas in sculpture accelerated.

If it hadn't been for González perhaps no one would ever have known what is beautiful about welded steel. He showed that rods and rectangles and squares and circles of metal could be put together in compositions that were like songs in space. His works were vastly different from Moore's mountainous landscapes of form; they were light and airy, delightful and playful, sometimes dazzling in their brilliance. Although they looked different from anything called sculpture in the past, they met the classical test of being impressive combinations of form no matter which way and from which angle one looked at them.

About the time that González was breaking new ground with his welded construction, Alexander Calder appeared on the American scene with his unprecedented mobiles. Suddenly sculpture became movement in these strange discs fixed miraculously onto wires, so perfectly balanced that they literally floated in the air, so brightly colored that they seemed like speckles of light. These mobiles were copied and imitated endlessly, but only Calder's original creations had that magical quality that made them perfect creations in space as they moved perpetually through the air. Even when Calder moved on to stabiles, his sense of grace enabled him to create endlessly captivating forms. This was not sculpture of the heart and soul, as was the case with Moore, Marini, and even Gonzáles, sculpture that, one might say, was made of the flesh and blood of sculptural materials. It was a cerebral form of sculpture, brilliant, mesmerizing, dazzling.

These and other pioneers were followed by many ingenious creators of new forms. One of the greatest was David Smith, who welded together discarded metal parts from automobiles and other objects and created a remarkable harmony in the way they fitted together. You can put your hand into the spaces of his finest pieces and sense that the air is part of the sculpture, as if his forms made the air vibrate and become a living thing. There is an inventiveness about the way he arranged the pieces he welded together and a genius that enabled him to produce a perfectly balanced form out of the most ordinary objects. Toward the end of his life he developed a variation of his theme of welded metal by composing large square- or rectangular-shaped stainless steel, each of which contained curving and twisting highlights in the metal created by his method of polishing. Called *Cubi,* these sculptures look different from his earlier welded pieces, but if one remembers that balance is the key to Smith's achievement and that his special style of balance has an unmistakable character, they all seem to belong together

Left: Julio González. *Head on a Long Stalk (Tête Longue Tige).* 1932–33. Iron, 27⅛ × 8⅝ × 5⅛". Kent Fine Art, Inc., New York

Overleaf, left: Isamu Noguchi. *Momo Taro* (detail). 1977. Granite, 9′ × 35′2″ × 22′8″. Storm King Art Center, Mountainville, New York

Overleaf, right: Louise Nevelson. *City on the High Mountains* (detail). 1983. Cor-ten steel, painted black, 20′6″ × 23′ × 13′6″. Storm King Art Center, Mountainville, New York

as one body of work. During the 1980s there were great exhibitions of Smith's work in the National Gallery of Art and the Hirshhorn Museum, both in Washington, D.C., but the most outstanding permanent installation of his sculpture can be found at the Storm King Art Center in Mountainville, New York.

When we think of the last several decades, many sculptors come to mind, but because we are so close to what is happening, it is difficult to single out those who are most outstanding. Eventually, as in all other periods, two or three will stand out above the rest.

One of these will undoubtedly be Isamu Noguchi, a Japanese-born American who has taught us the beauty of natural rock formations, assisted by a sensitive sculptor's restrained intrusions. His goal is to bring out the inherent beauty of the substance by shaping it or breaking it carefully so as to enhance its natural qualities. One stone on the grounds of the Noguchi Museum in Queens, New York, seems to have simply received a hammer blow to break it apart; the artist was so moved by the way the rock cracked that he left it just as it was. Another beautiful reddish stone on the grounds looks magnificent against a blue sky. His tall stone piece on New York's Fifth Avenue, just south of The Metropolitan Museum of Art, stands as a silent sentinel reminiscent of eternal truths in the midst of the hustle and bustle of a busy street. A particularly fine work of his, called *Momo Taro,* consists of eight giant stones shaped out of huge granite boulders and placed in a dramatic setting on a hillside made especially for it at Storm King. One of the stones has a deep round hole carved into it, another a shallow, smaller hole; both have flat surfaces facing toward the sky like giant antennae communicating with the stars. Some of the other stones have serrated edges or are cut into like benches. When looking up at it from distance the sculpture is a strong, white presence that forms a natural crown to the green, grassy slope and marks off decisive shapes against the

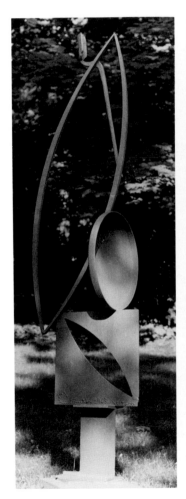

David Smith. *Voltri Bolton XIX* (Voltron XIX). 1962. Steel, 94⁵/₁₆ × 20 × 24″. Private Collection, New York

foliage of the trees behind it. Moving close to the sculpture one sees a beautiful combination of rocks that has the grandeur of a natural formation. As one walks around the hill and sees the white, rocky forms emerging from the crest in different ways, there is something pure and moving in the forms. Once I photographed the work from a helicopter in connection with a book I was doing on Storm King, and it looked like an ancient skeleton that had been there for thousands of years and was as much a part of the landscape as the mountains in the distance.

Another kind of sculptural brilliance can be found in the sculpture of Louise Nevelson, who found a unique way to make well-composed assemblages out of a miscellany of objects and shapes. Her works got larger and larger over the years, and although initially she made all of her assemblages out of wood, in later years she had them cast into bronze. One can appreciate the sculptural quality of these works by exploring the various details and discovering the ingeniousness with which she combined forms and textures to compose works that are intriguing from all sides and angles.

These abstract shapes are part of our generation's approach to breaking out of the mold of the past. The desire to do so is not peculiar to us; it happens in every era. Once we realize that there were periods of art in the past in which decorative rather than figurative forms were the subjects of master works, we can see these contemporary explorations as part of the great tradition of sculpture.

The fact that these works are innovative, and are new ways of creating three-dimensional realities, does not in itself determine their worth as sculptures. They provide important new visions of the world around us and are there for us to appreciate as contributions to our way of seeing and experiencing form. We can decide for ourselves how we feel about these works, recognizing that posterity will make up its own mind about which sculptors will become part of the permanent history of art.

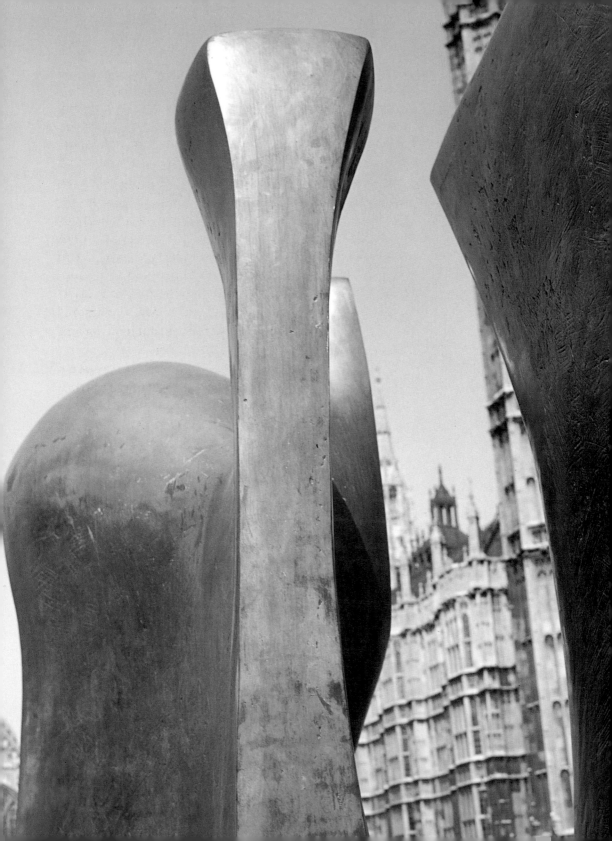

LIVING WITH SCULPTURE

Once, when I was photographing a Henry Moore sculpture in a small park facing the House of Lords in London, I asked a policeman standing nearby if it would be all right to walk on the grass. It was okay with him, he said, but he wondered why I wanted to bother. "It's a beautiful sculpture by Henry Moore," I explained. He laughed. "That piece of junk!" he exclaimed. "If you didn't know it was by Henry Moore, you wouldn't give it a second look." I was indignant. "If I could have an hour of your time," I said, "I know I could show you what is beautiful about that sculpture." He laughed again. "Mister," he told me, "if you spent a lifetime, you couldn't show me what's worth looking at in that ugly thing."

I later told Moore the story because I knew he would be amused. It wouldn't bother him that there were people who failed to appreciate what he was trying to do. Some individuals just cannot understand sculpture, and the London policeman sounded like such a person. Besides, he knew that, as is the case with any of the arts, it takes a long time for new sculptural ideas to become accepted.

My own feeling is that people can learn to appreciate new ideas in sculpture if they give themselves a chance. The trouble is that when the work is left to speak for itself (which is what it is supposed to do), a lot of people just don't listen.

If you take a walk around any museum in which there is an exhibition of contemporary sculpture, you are likely to find someone snickering at a John Chamberlain object that looks like an automobile wreck, at a creation by Claes Oldenburg that looks like a giant electric plug, at a work by Richard Artschwager that looks like a chair, at a pile of neatly stacked railroad ties by Carl Andre, or at a collection of blankets by Joseph Beuys—none of which seems to make any sense. You may be put off by them and think

Henry Moore. *Knife-Edge: Two Piece*. 1962–65. Bronze, length 12'. The House of Lords, London

129

it is ridiculous to call these things works of art. You may be convinced that the sculptors have hoodwinked the museums and are trying to put something over on the public.

These are predictable reactions to works of art that strike out in new directions. It is natural to be startled, mystified, even skeptical about revolutionary sculptural concepts. The shock of a new work is inherent in the way the arts develop in our society. But to dismiss such works as nonsense is to cheat yourself. You should realize that whether or not you like the work, the artist who created it was serious when creating it and that knowledgeable museum curators believe it deserves serious attention from the art world. It is up to you to figure out why. If you are blind to what the artist has created, and you scorn rather than explore what is in front of you, then you will see nothing. On the other hand, once you have a sense of the artist's feelings about his or her work you will at least understand why the curator chose to exhibit it. You should be willing to open your mind to a new work, which you can do only if you leave behind your skepticism and let yourself enjoy a new kind of aesthetic experience.

When you encounter sculptural forms that are baffling, remember that sculpture is an art form that can help you see the world around you in fresh ways. You may find that Chamberlain's bent and twisted metal pieces from an automobile wreck make a somewhat dazzling composition, and Andre's railroad ties focus your eyes on a richness of the material you had never noticed before. They are works that open your eyes to an aesthetic quality of everyday objects. You can even begin to think of a three-way electric plug as a legitimate subject of creative expression when you see Oldenburg's oversize sculpture of one. In other words, give yourself—and the artist—a chance by considering the concept behind the sculpture and letting your eyes tell something to your heart before condemning it.

Carl Andre. *Trabum.* 1977. Douglas fir, nine units each 12 × 12 × 36″. The Solomon R. Guggenheim Museum, New York

Opposite: John Chamberlain. *Dolores James.* 1962. Welded and painted automobile parts, 76 × 97 × 36″. The Solomon R. Guggenheim Museum, New York

One recent trend has been given the descriptive phrase of "site specific sculpture," and one of the leading exponents of this concept is Richard Serra. His large Cortan steel plates, sometimes curved, sometimes extending like a multisided wall, have created a storm of controversy in many public places for which they were created. A work called *Twain* was created for a square block in downtown St. Louis, where there has been a public outcry for its removal ever since it was installed. It is frequently scorned as an impoverished neighbor of the magnificent *Arch* by Eero Saarinen, which towers into the sky and is one of the most successful public monuments in America. Recognized by all as an extraordinarily graceful form, *The*

Arch is as widely loved as Serra's work is disliked. When I first saw the simple, stark Serra wall, I wondered what sculptural quality I could possibly find in this larger multisided wall, which was about six feet high and had openings in it every ten feet or so through which one could walk or look out at the city. That was all there was. Where, I asked myself, are the organic forms I so loved in Moore's work or the brilliant designs of the sculpture of David Smith or the fascinating shapes in Nevelson's compositions? This was just a wall; what was there to look at? But then as I walked around and opened my eyes and mind to try to see what the artist saw and felt, I began to respond to the starkness of the shapes as they cut into the view of the city and sky beyond. The spaces in the wall were like windows through which one could see framed

Richard Serra. *Twain.* 1976–81. Cor-ten steel plates, 120′ × 83′. Gateway Mall, St. Louis, Missouri

compositions; they were in effect like my own camera lens which would outline sections of the world around me and make me more conscious of the arrangements of forms in those sections. Then I noticed that the sun was casting shadows on certain sections of the wall and lighting up others, and that the sculpture was also throwing shadows on the grass and forming striking compositions there. After spending quite a few minutes on the site I came to feel that Serra's structure enabled one to experience this particular city environment in ways that were not possible before. It was an instrument of visualization, and like all three-dimensional works, it provided an infinite number of viewpoints from which one could study the different elements and the surrounding area.

What is hard to understand about Serra's work is that there is little *there* to look at in itself; the *there* there is the entire space that can be seen and felt around the work and what the work does to that space in your eyes as you look around you. This is why the phrase "site specific" is so apt: this steel structure in another area would produce an entirely different effect, and that effect would have nothing to do with what the sculptor wanted to accomplish with his work. It is much the same as putting *Stonehenge* in St. James Park in London rather than in the vast landscape selected by the artists of several thousand years ago. This is a different kind of sculpture, but it belongs in that long tradition of creating a new kind of reality that reveals an aspect of the world one may not have seen before, and which makes a powerful aesthetic impact.

Another direction sculpture has taken in our time is the work that makes a statement for a brief period of time and then disappears. Christo is the major figure in this respect, with, among other works, the curtain he hung between two mountains in Colorado, the running fence he erected across the California landscape, the plastic flowers he floated around Florida islands, the wrapping of the

Pont Neuf in Paris. Here, too, one's first reaction may be incredulity that this can be considered art, but then as one sees all the sketches Christo made for the project, reads about the event in the press, and sees photographs and films of what his projects looked like while they were in place, one gets the sense of a major aesthetic adventure. In a sense these are the antitheses of the enduring qualities that characterized the great sculpture of the past; on the other hand they are very much in tune with the quality of impermanence which characterizes our era, with its appetite for built-in obsolescence and its obsession with ever-changing tastes and fashions. And there is a sense of form in these works; they call our attention, for instance, to the beauty of the rolling hills of the California landscape or of the islands that dot the Florida coastline. These views are so commonplace to our eyes that we tend to overlook their aesthetic qualities, but Christo has made us see them as decisively as Pissarro or Monet or Van Gogh made us see the French landscape with a fresh eye. We may or may not be moved by Christo's works, but they can open our eyes to a new way of looking at the world around us.

Still another approach to sculpture in our era has been the development of earthworks in the United States. One of the first works of this genre was *Spiral Jetty* by Robert Smithson, a 1,500-foot-long pile of stones created in 1970 on the flats of the Great Salt Lake in Utah. Aerial photographs of this giant form have become something of an icon of our age. It seems as if modern man has created a form in the earth that might be seen by visitors from outerspace, conveying to them some elemental message about our civilization. Walter de Maria's *Lightning Field* is equally impressive in scope; it consists of four hundred steel poles averaging twenty feet high, placed in a mile-long rectangle in a remote area of New Mexico. This creates a veritable dance of light during heavy storms as lightning finds its way to one or another of the poles. A

monumental interaction with the elements, it is reminiscent of the ancient earthworks that have recently been discovered in aerial observation flights over Peru and which suggest that thousands of years ago our ancestors were as concerned as we are about communicating with the heavens above.

This does not mean one has to like, or that posterity will hold in high esteem, all sculpture exhibited in public and written about enthusiastically by critics. A friend of mine, Phil Berman, who has as open a mind to new sculptural forms as anybody I know, was appalled on a 1987 trip to Germany to see that in two major international exhibitions the artists needed to describe their ideas in words because their sculptures failed to speak for themselves. "The sculptures without the story," he wrote in a letter describing his experiences, "were in most cases a zilch [meaning nothing]. In fact, if they [the artists] wrote the legend and didn't burden...the art world with the objects, they would have gotten higher marks. The sculptures detract from the story....If you have to have it explained, they have missed the point." Among the sculptures he described was "a landboat that is one hundred feet in length with trees on it, a cabin, water around it and going nowhere. The home owners living nearby had the city purchase it as they felt it would make their property more valuable, having culture, et al, even though to a person, no one living there liked it."

If some sculptures shock the public by being different, others are ignored because they are not in the spotlight. That is certainly true in museums where the paintings seem to be the main focus of interest and sculptures appear to be installed as decorations to fill in the empty spaces. In many galleries this is the fault of the installation; but in others it is a problem created by the habitual way in which museum goers tend to walk through museums. The names of painters are almost always better known than those of sculptors, and since visitors are often

guided by labels in deciding what they should look at, sculptures by unfamiliar artists tends to get short shrift. Perhaps after reading this book, more visitors will overcome the tendency to ignore the sculptures in a gallery and take the time to look at them more carefully. Perhaps they will also look at them with a more searching eye, moving around the sculpture to make their own discoveries, examining the details, and appreciating the way the sculptor worked with his materials.

Contemporary sculpture in public places also tends to get little more than passing notice. We are always too busy to stop and look at the increasing number of sculptures in the streets of our cities, our workplaces, hospitals, concert halls, hotels, public buildings, and university campuses. These sculptures seem to many observers more like architectural decorations than important works of art. The modern proliferation of sculpture in the open air had its greatest impetus when Henry Moore's work became sought after as the symbol of excellence in public places around the world. Today there are sculptural projects everywhere, and Moore has been joined by a variety of artists whose work lends itself to public siting—Picasso, Calder, Nevelson, Noguchi, Tony Smith, and many others.

The problem with this explosion of public sculpture is that it hasn't really taught us to look. A Louise Nevelson sculpture on New York's Park Avenue or in the lobby of the Hyatt Hotel in Kansas City receives no more attention than the traffic lights on the street or the sunburst chandeliers that hang from the hotel ceiling. Of course many public sculptures are not important works of art, but the question of whether they can have meaning to you is still worth exploring. You will never know if they can touch you or extend your vision unless you take a few moments to look.

No doubt the ubiquity of sculpture in our time represents a major change in our outlook toward the visual arts.

In the past, most public sculptures were devoted to monuments commemorating historic figures (they were called *statues* rather than *sculptures*), and although they were intended to honor the famous people of an era as well as heroes like the biblical David, they tend to be looked upon as landmarks rather than fine works of art. That is still true of commemorative works in our own time. I recently had lunch at the home of a friend who lives across the street from a park, and when we walked out of the building I pointed to a monument opposite the entranceway that I thought was quite impressive. He confessed that although he had lived there for years, he had never noticed the monument. He had no idea who the sculptor was or to whom the work was dedicated. I suspect the same is true of most people who walk past monuments in the course of a busy day.

The great cities of the world are dotted with sculptures on major squares and in public parks. Hundreds of them stand in New York, Washington, Chicago, London, Paris, Rome, Tokyo, and practically no one looks at them. Some sculptures in front of famous buildings such as St. Paul's Cathedral in London are ignored as merely historic or decorative. Others are situated so high above the ground that it is virtually impossible to see them, like the figure of Columbus on top of the column in New York's Columbus Circle, or the figure of Lord Nelson on top of the column in London's Trafalgar Square. These may or may not be great sculptures, but it can be said without reservation that they are deserving of more of our attention than they get. Moreover, not every sculpture has to be great in order to be appreciated.

To help develop our awareness of and taste for sculpture, a number of outdoor sculpture museums have recently sprung up where sculpture can be seen in ideal environments. The rolling hills of Storm King provide a marvelous setting for sculptures by David Smith, Calder, Lieberman, Moore, Noguchi, and many others whose

works take on a majestic air that is inspired by the landscape. Laumeier Park in St. Louis is another beautiful area for contemporary sculpture; there are not only rolling hills but also groves of trees in which one can come upon clearings made especially for particular sculptures. Brookgreen Gardens in Myrtle Beach, South Carolina, is a striking southern landscape in which hundreds of figurative sculptures are placed tastefully on beautifully maintained grounds. The Hakone Open-Air Museum near Tokyo and its companion museum Utsukushi-Ga Hara are high up in the mountains and provide unparalleled vistas for the viewing of contemporary sculpture. The Yorkshire Sculpture Park north of London takes full advantage of the beautiful English countryside as an environment for sculpture. Many other outdoor museums around the world have come into existence in the last few years to help people appreciate and respond to sculptural works. They are worth visiting not only because of the particular sculptures that are exhibited but because they

View of the *Hakone Open-Air Museum*

provide an experience of being with sculpture for several hours as one walks around the grounds. There is no better way to open the eyes and heart to the unique qualities of three-dimensional works of art.

The great contribution of these sculpture parks is that they provide scenery to accompany the sculptural forms of the exhibited works. For when one looks at sculpture one sees what is in the background as well as what is in the foreground. The eyes take in the whole scene, and the sculpture becomes part of its background and the background part of the sculpture. You need only see a photograph of a work of sculpture from any position to realize that the picture shows the background just as clearly as the sculpture; and that is what your eye sees as well. If there are jarring elements in the background, such as street signs or flashing lights or a jumble of buildings or moving cars, they interfere with the enjoyment of the work. But when there is a fortuitous blending of scenery with the forms of the sculpture, the whole effect is enhanced and your aesthetic experience is elevated.

There is an echo of this experience when a great work of sculpture from the past is seen in a museum located near its original site. It is exhilarating to see the fifth-century B.C. *Charioteer* in the museum in Delphi, outside of which are the hills where the temple stood and the deep valleys and towering mountains in the distance. The same is true of seeing sculpture in the museums in Luxor, or Kyoto, or Jerusalem, where an awareness of what is outside the building is part of one's consciousness of what is inside. That is not to say that one is not thrilled when seeing the Parthenon reliefs (the Elgin Marbles) in the British Museum, or Oceanic and African art in the Michael Rockefeller Wing of The Metropolitan Museum of Art, or the collection of Chinese sculpture at The Nelson-Atkins Museum in Kansas City; but something worthwhile is added when one can see works of sculpture in their native land.

It is also especially meaningful when one can see a great work of sculpture in the spot for which it was created. This is true of the great cathedrals of Europe, many of which have literally hundreds of sculptures on their facades and in their interiors. I remember the first time I climbed up to the roof of the Milan Duomo, with its almost endless array of spires, and was amazed at the number of sculptures there, many of which could not be seen from the street below. The same is true of the array of sculptures in Chartres, Rheims, Strasbourg, Wells. In these and other cathedrals built over a period of hundreds of years, one gets the feeling that the sculptures were created more for God than for man, and that when we look at them we are in touch with the profound devotion that inspired this massive output of creativity.

The problems of preservation and restoration are making it increasingly difficult to see certain masterpieces of sculpture in their original sites. In some instances the authorities have found it necessary to place casts of sculptures in their outdoor settings while the works themselves are removed to museums where they can be protected. This gives us an idea of what the sculptures looked like in their rightful place, but casts tend to have a shallow or empty look to the discerning eye. One need only compare the cast of Donatello's *St. George* in one of the niches of Orsanmichele in Florence with the original in the nearby Bargello Museum to see the difference. The original has a solidity, a nobility that is missing in the cast. Yet there is no other solution if the works are to be preserved.

Maintaining outdoor works in our polluted environment has become one of the greatest challenges facing the art of sculpture today. I became aware of its seriousness years ago when I was working on a book on the sculpture of Donatello. I had been all over Italy photographing his work, as well as in Germany, England, and the United States, but there was one work I was unable to photograph, the exterior pulpit in the cathedral of Prato. I

had seen the pulpit some years earlier and knew it to be quite beautiful, but when I went back to photograph it for the book, it was gone. It turned out that it had been removed from the cathedral for restoration. Every time I went back to Italy, I inquired of the authorities if I could photograph it while it was being worked on (as I had done with several other Donatello sculptures that were being restored). Repeatedly I was told that it was not ready and that I should write again before my next trip. This went on for several years, and finally I went to the highest authority and told him that everything had been photographed but the pulpit and the book would have to be published without it. He looked at me angrily, grabbed me by the arm, and took me through a series of long winding halls into a room deep in the interior of the building. He turned on a light and pointing to fragments of sculpture on the floor said, "There is your pulpit! It is in such bad condition that if you touch it it will turn to dust." He explained that restorers had been struggling for years to find out not only how to preserve it, but also how to make a cast for the cathedral without destroying the original. So far they had not found a solution. "Preserving that sculpture is more important than your damn book!" he told me. "However, since you are so persistent, you can bring your camera equipment in here, and if you can photograph some of the details without touching anything, go ahead and do it." I couldn't believe my eyes. It was shocking to see the pulpit in pieces. But I did spend a day alone in that room, taking photographs of as many details as I could, trying to focus my camera on it from angles that would show how passersby would have seen it in its original position. I felt as if I were in the presence of a dying work of art and that only the miracles of modern science might be able to save it.

Unfortunately, a large number of casts of a work can make it so common that it becomes a cliché. It is for that reason that most sculptors limit the number of casts to

three or six or at most twelve. Rodin has been criticized for leaving a will that permits the Rodin Museum to make additional casts as a means of raising money, and it is said that there are as many as eighty casts of some of his more popular subjects. Rodin's *Thinker* can be seen in front of university buildings all over the United States, and eventually it can be taken so much for granted that unless one makes the time to look at the details or see it from an unfamiliar vantage point, it tends to lose its power.

Replicas now available in large quantities in museum shops pose an even more difficult problem. A replica is not cast from the original; it is reproduced by an artist who copies it, and the copy is then cast and manufactured for sale. A copy can never be the same as the original; it lacks the unique quality that makes the original a great work. The result is that owners of the replicas will have an opportunity to appreciate only the more superficial aspects of the work, its general shape rather than its inherent strength.

One should make up one's own mind whether one wants to live with replicas. After seeing a work that made a profound impression on you, you may want to take a reproduction of a work of sculpture to remind you of the experience you had. I did that myself when I first saw the doors of San Zeno in Verona and have enjoyed looking at a small metal replica from time to time, although I realize that it is a far cry from the original. It is only a reminder of what the work is like, not a real duplicate. The replica of a masterpiece can never be a masterpiece itself, but it can help recall the experience of being in the presence of the great original work.

On the other hand, with the democratization of art through reproductions of paintings and the publication of art books, there is no doubt that replicas can add to our enjoyment of sculpture. Indeed some contemporary sculptors have created "multiples," which are works that can be created in very large quantities. They feel that

Milan Cathedral. Begun 1386

more people should be entitled to have "original" works of sculpture in their homes, and multiples make that possible.

More important than the question of buying replicas or multiples for one's home is what the opportunity to live with original works can mean to you. For living with sculpture can add something unique to your daily life. Every day as I leave my home, I look at the extraordinary sensitive forms in a sculpture by the American sculptor Saul Baizerman, which my wife and I acquired some years ago and which stands next to our front door. Every night when I come home, I see it again. Always I feel as if I am seeing something I never saw before and think how lucky I am to have such beauty in my daily life. I am eternally grateful to the sculptor for having created this remarkable work and think how fulfilled he would be to know how his work has enriched our lives.

Of course, works by famous sculptors are sought after by leading collectors, and the demand on the art market has made them very expensive. But there are many young sculptors whose works can give you much aesthetic enjoyment yet can be acquired for relatively modest prices. There are galleries in every major city in the world today and exhibitions in museums of contemporary sculpture in which a great deal of the pieces can be purchased through the artist or a dealer. Reviews in newspapers and art magazines that include photographs of the works can give you an idea of what to look for.

To love sculpture, and to live with it, can be an extraordinarily rich experience. Its greatest reward is that you the viewer are in part the creator, for a fine work of sculpture invites constant exploration. If you find sculptures that grow on you the more you look at them and you have an opportunity to acquire them for your home, you will be adding a sense of beauty to your life that will be never-ending.

Saul Baizerman. *Elegy* (detail). 1933–39. Hammered copper, height 8'. Private Collection, New York